ART OF EVERYDAY PHOTOGRAPHY

Move Toward Manual & Make Creative Photos

SUSAN TUTTLE

NORTH LIGHT BOOKS
CINCINNATI, OHIO
CREATEMIXEDMEDIA.COM

Contents

Introduction

Dear Reader,

You are holding this book in your hands because you have a passion for photography and you wish to improve your knowledge and skills so that you can make the best, most beautiful photos possible. Notice I said *make* and not *take* as there is a distinct difference between the two. This book is all about *making* photos. When you *take* a photo in full Auto mode, the camera makes all the decisions for you. Sometimes this serves your creative vision (if you're lucky), but often it doesn't. This is because your camera does not have a brain and does not know what your creative intentions are. It doesn't know, for instance, if you want to blur your background for a portrait, freeze motion for an action shot, or create a long exposure to capture motion progression.

This book is infused with my passion to teach you how to get your DSLR out of full Auto mode and to best use and control its features to *make artful photos that are a realization of your creative intentions*.

In Chapters One and Two, I'll take you from full Auto mode to full Manual mode, exploring everything in between. We'll talk about exposure (how aperture, shutter speed and ISO work together), metering modes, lenses and choosing appropriate ones for your needs, the types of light and how best to shoot with each kind, dealing with tricky lighting situations, white balance, tips for getting tack-sharp photos, composition possibilities, breaking rules for creative reasons, and useful accessories.

In Chapters Three through Six, I'll show you how to apply the information from Chapters One and Two to many types of photography. This book is all about choices. You get to learn at your own pace and shoot in any mode that is most comfortable for you at the time. There will be lots of helpful tips to support you along the way, to meet you right where you are, as well as encourage you to grow in your craft. You will actually start to see improvement in your photography immediately, just by applying a few new tips from this book. And the more you learn and apply, the better your photos will become. Always remember that *shooting from the gut* is and always will be the most important factor in making photographs that capture beauty and truly move people. If you knew how to best use your tool in conjunction with your artistic intuition, think how amazing your photography could be.

I've checked out photo upload data from Flickr, and guess what I found? Can you name the photographic device that most of the uploads come from? You would be correct if you said a mobile phone. I myself am an avid iPhoneographer as well as a DSLR photographer and enjoy both tools for different reasons. Because so many of us shoot with a mobile device, I have made sure to devote portions of this book to mobile photography.

Mobile photography tips and techniques are actually woven throughout this book, and you'll meet not only talented DSLR contributing photographers but many mobile photographers who are top-notch in their field. Please note that I have made a conscious decision to use the term *mobile photography* as opposed to *iPhoneography*, for the sake of being all-inclusive, whether you use an iPhone, iPod Touch, iPad, an Android device such as a Samsung Galaxy smartphone or a Windows phone like the Nokia Lumia 1020.

The reality is that most photography apps out there are produced for iPhone, iPod Touch and iPad devices. The number of photography apps for other devices remains

low, and the number of photography apps made with versions for both Apple and Android (known as a universal app) is even lower. This could change, and for that reason, I will stay away from classifying apps as being either for Apple mobile devices, Androids or a Windows phone. The speed of technology is sometimes unpredictable.

In addition to information on mastering the technical aspects of your DSLR to make better photos, I also give a plethora of helpful tips and techniques you can apply to your photography, whatever your camera type or device. We will explore a variety of photography styles such as portraiture, still-life and food photography, landscape and nature, and everyday life and travel. You can get access to additional photography and photo-editing tips at CreateMixedMedia.com /artofeverydayphotography.

You have a passion for photography and you shoot from a soulful place deep within you. It's just like any other art—like dancing, painting or playing a musical instrument. The need to create and express oneself is there, and all you need is a medium for expression. Once you have mastered and are in full control of your instrument, you can use it to best convey what's in your heart. With photography, that means making photographs of what matters deeply to you, in a refined, creative and powerful manner.

Warmly,
Susan

Make
BETTER PHOTOS
Right Now

You don't take a photograph,
you make it.

» Ansel Adams

Your camera is a tool, plain and simple. When it comes to *making* stunning photographs, you, the photographer—with your artistic eye—matter the most. *You* are ultimately what will make all the difference between a technically good photo and a stunning photo infused with something that is hard to put into words but has the power to strike the viewer in the emotional gut. Whether you shoot with a digital SLR, point-and-shoot or mobile phone, it is paramount that you understand how to best use your tool to help you realize your creative vision.

This chapter focuses on getting to know your DSLR—the basics of how it works, an introduction to your DSLR's various exposure modes, demystifying the exposure triangle (aperture, shutter speed and ISO), an introduction to your camera's built-in light meter and information on why it's useful, and a helpful survey of lens types.

Mobile photography tips will be woven in throughout, and we'll take a breather halfway through the chapter with my Top Tips for making awesome photos right now! No matter your device or skill level, you can apply these top tips to your photography today and see immediate improvements in your photos. At the end of the chapter we'll take our first steps away from your DSLR's full Auto mode and begin the journey of learning how to use all that your DSLR has to offer in order to make more creative photos.

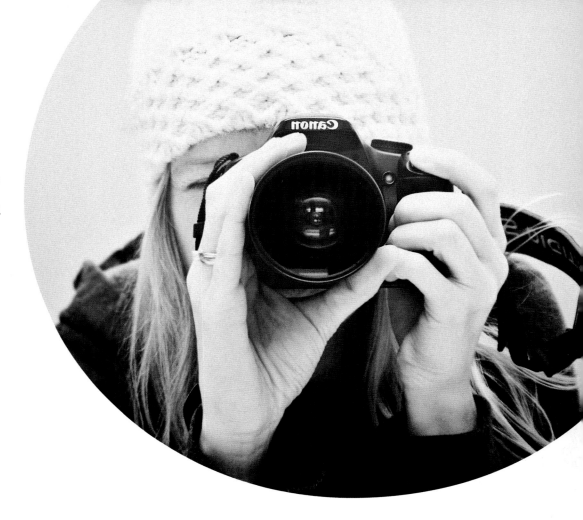

When it comes to using your DSLR, it's all about being in the driver's seat and controlling its features to yield well-exposed, in-focus, creative photos.

How Your Digital SLR Works (The Very Basics)

Welcome to your digital SLR camera! Don't worry, I'm not going to get overly technical here but will share a few key points on how that digital-dream-of-a-black-box in your hands helps you, the artist, make a photograph. Notice I didn't say "take" a photograph, and you will see why as this book unfolds. I don't exaggerate in my ode to this ingeniously engineered tool. Once you fully realize all that this box is capable of, I think you will be in awe too!

DSLR stands for digital single-lens reflex. Fundamentally, a DSLR operates much like a 35mm photographic film SLR camera, only it is digital as opposed to analog and offers features that are not present in a 35mm film camera. DSLRs first came on the photography scene in the 1990s, but didn't gain popularity until the turn of the century.

For bonus goodies and information on this book's e-companion, visit CreateMixedMedia.com/artofeverydayphotography.

7

What Happens When You Snap a Picture With Your DSLR?

The camera captures the scene you see in your viewfinder (or on your LCD). In a nutshell, when you press the shutter release button, a fixed amount of light travels through the lens and hits the camera's image sensor for a fixed amount of time. For this to happen, a mirror flips up and out of the way and the shutter opens, allowing the directed light to hit the image sensor. Think of the sensor as being comparable to the photographic film in an analog camera. The sensor captures the light and creates the digital image from a synthesis of red, green and blue tones of varying brightness. The fixed amount of light that hits the sensor is determined by the aperture's size (the *aperture* is the hole in your lens), while the fixed amount of time that the light hits the sensor is determined by the *shutter speed*. Aperture and shutter speed can be set automatically by the camera to yield a proper exposure (although the camera can't always achieve it), or they can be manipulated by you in a number of ways. The latter yields much better photos, as you will soon see.

Two Key Features of a DSLR You Should Know About

Interchangeable Lenses

One of the most exciting aspects of a DSLR lies in the fact that you can use a variety of different lenses with it. Each type of lens produces a different creative result, so in essence you can rig your camera with lenses that best match the types of photos you want to make.

Full-Frame and Cropped-Frame Sensors

DSLR image sensors come in a variety of sizes. The larger-sized sensors found in higher-end DSLRs are referred to as full-frame sensors and are the same size as their 35mm analog predecessors. The smaller sensors found in most DSLRs are called cropped-frame sensors (there are APS-C sensors and APS-H sensors). Full-frame DSLRs produce photos with a greater field of view than cropped-frame DSLRs do, so they capture a wider angle of the scene. If you want to achieve the same field of view with a cropped-frame camera, just take a few steps back or use a wide-angle lens to compensate. Cropped-frame DSLRs allow you to zoom in more than full-frame cameras, which is great for portrait photography. Smaller sensors will be more than adequate when it comes to image quality and can produce amazing results—in fact, there are lots of professionals who use them.

OK, now feel free to forget about most of what I just said, especially the mechanical/operational stuff, because understanding that information has little or no bearing on creating stellar photos with your DSLR. When it comes to using your DSLR, it's all about being in the driver's seat and controlling its features to yield well-exposed, in-focus, creative photos. And that's what I'll be showing you in the pages of this book.

How to Use This Book, A Stepping-Stone Model

It's very important to me that you, regardless of the amount of experience you have with your DSLR, be able to start making better pictures right away. I want you to feel free to use this book in a flexible manner, at your own pace, skipping to the sections you love, making photographs of what you love immediately!

I've designed the book around what I call a stepping-stone model, which naturally aligns with the range of control your camera provides, from full Auto mode to Manual mode and everything in between.

If you still want to shoot in full Auto mode for a while, by all means do. There are plenty of tips, techniques and ideas throughout the book that you can start applying to your photography right away. If you already know about some of the more basic information, proceed to the more advanced stuff. I do recommend that you use your DSLR's instruction manual in conjunction with this book, because although the settings and features discussed are accessible on any DSLR, each brand, as well as different models within a given brand, functions a little bit differently.

I should also add that camera instruction manuals sometimes lack information or have unclear information. If you can't find the information you need in your manual, do a Google search for it: Type your camera make and model and the feature you have a question about in the search box. YouTube videos with demonstrations are the easiest to follow because you can actually see how it's done.

For bonus goodies and information on this book's e-companion, visit CreateMixedMedia.com/artofeverydayphotography.

9

A Synopsis of This Stepping-Stone Model

When you're ready, we'll take our first step away from full Auto mode and begin to explore your camera's other exposure modes.

Scene Modes

We'll start with the *Scene* modes, modes such as Portrait, Macro, Sports and Landscape, which can be found on your DSLR's mode dial. These Scene modes inform your camera of the type of photo you wish to shoot, and your camera in turn automatically chooses settings it thinks would best capture the shot.

The Scene modes are better to use than full Auto mode because they give your camera some insight into the creative goals you are trying to achieve; for example, *Sports* mode will yield a fast shutter speed to freeze motion.

Program AE

From Scene modes we move on to *Program AE* (automatic exposure) mode, frequently referred to as P mode. In P mode, the camera takes care of the aperture and shutter speed settings while you are free to explore some of your camera's other settings and features like the metering modes, exposure compensation, white balance, controlling ISO, AF (autofocus) modes and AF point selection.

Both Scene modes and P mode can be excellent teaching tools, but I don't recommend shooting blindly with them. Take note of the camera settings that are generated for different situations. It will make learning how to control your camera in the more advanced exposure modes a lot easier.

When you feel ready to gain more control of your DSLR and thus improve your photos even more, it's time to explore the two semiautomatic exposure modes, which are Aperture Priority mode (displayed on your camera's dial as A or AV, depending on the make of your camera) and Shutter Priority mode (displayed as S or TV, depending on the make of your camera).

Aperture Priority Mode

In *Aperture Priority* mode, you, the photographer, dial in the aperture setting while your camera takes care of choosing the shutter speed in an effort to yield a well-exposed photo.

Shutter Priority Mode

In *Shutter Priority* mode, you set the shutter speed while the camera takes care of the aperture setting in an effort to produce a well-exposed photo. Why are these modes important? Well, because the camera does not have a brain. It doesn't know if you want to freeze motion or have a nice blurry background for a portrait. All it cares about is yielding proper exposure.

When you use these semiauto modes, you tell the camera how to best serve your creative goal for the shot. Also, I should mention that it is important to take note of what the camera does in reaction to the setting you choose (meaning, if you set the aperture size, take note of the shutter speed setting that the camera generates, and vice versa). As you explore the semiauto exposure modes, it's also important to continue to master some of your camera's other features that you first explored in P mode (the metering modes, white balance, controlling ISO, AF modes, etc.).

All of this mindful practice and observation will make utilizing full Manual mode a piece of cake!

This stepping-stone model, although it progresses from the basics to the more advanced, is not completely linear. Shooting in Manual mode is not always the most supreme, best choice. (Some professional photographers disagree with me, and others share my opinion.)

Depending on what type of photo you are shooting, you might choose Aperture Priority mode or Shutter Priority mode over Manual mode. I myself shoot mostly in Aperture Priority mode and sometimes Shutter Priority mode when freezing or capturing motion progression is paramount. I move to Manual mode only when I need

creative control of both aperture and shutter speed for the shot. Many professionals do the same, while others prefer to always shoot in Manual mode. It generally boils down to a matter of choice and preference, as we will soon see (except for special cases where Manual mode is necessary, like when using studio strobe lights and for shots of fireworks and lightning).

When it comes to something like street photography, that dial often goes to P, even for professionals, as they don't want to miss that in-the-moment shot due to fussing over camera settings.

Icons Used in This Book

You'll notice that in Chapters Three through Six, I give tips that are coded with various icons. Each icon correlates to the amount of control you are ready to or wish to exert over your DSLR. I also weave in related mobile photography tips and pertinent photo-editing software tips, which are coded with icons as well. The figures here illustrate these icons.

Limited Control
(P Mode and Scene Modes)

More Control » (Aperture Priority Mode and Shutter Priority Mode)
Full Control » (Manual)

Mobile Photography

Post Processing

For bonus goodies and information on this book's e-companion, visit CreateMixedMedia.com/artofeverydayphotography.

11

Aperture, Shutter Speed and ISO— Exposure's Magic Three

Aperture, shutter speed and ISO—these are exposure's magic three. They work together to yield proper exposure and are known as the exposure triangle.

What is proper exposure? Overexposed photos are too bright and washed out, resulting in a loss of detail. Underexposed photos are too dark. A well-exposed photo is somewhere in between the two, where the tones are balanced and the important details are visible. The interpretation of proper exposure is somewhat subjective, and sometimes incorrect exposure may yield a desired creative result. A proper exposure can be achieved by manipulation of aperture, shutter speed and ISO in conjunction with a particular metering mode, which we'll discuss soon. Let's first talk about each part of the exposure triangle.

Aperture

That hole in your lens is called an *aperture*. It can be set to different sizes, and that's typically anywhere from f/1.4 to f/22. The bigger and wider apertures let in more light, while the smaller sizes let in less. So, if there is not much available light in your scene, a wider aperture can let in enough light for proper exposure. If the scene is very bright, a smaller aperture can let in less light and prevent overexposure. Aperture is measured by f-numbers (also called f-stops). Take note that *the smaller the f-number, the larger the aperture will be*, while *the larger the f-number, the smaller the aperture will be*. The trick to remembering this is to think backwards.

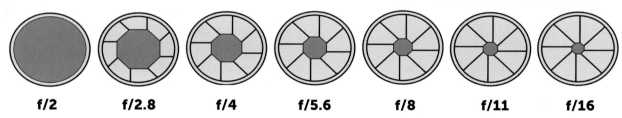

Ascending (opening up) → **Descending (stopping down)**

Shallow DOF
(Less of the scene is in focus)

Deep DOF
(More of the scene is in focus)

f/2 f/2.8 f/4 f/5.6 f/8 f/11 f/16

This figure shows the relative size of common aperture settings that are one full stop apart. The smaller the f-number, the larger the aperture will be, while the larger the f-number, the smaller the aperture will be. Keep in mind that today's DSLRs operate with fractional stops (fractions of a full stop), so they will have more aperture sizes than are shown here.

READ ME

When you descend from one aperture opening to the next, the f-number increases while the aperture gets smaller and cuts the amount of light going through the lens in half (e.g., moving from f/5.6 to f/8). This is called "stopping down."

When you ascend from one aperture opening to the next, the f-number decreases while the aperture gets bigger and doubles the amount of light going through the lens (e.g.: moving from f/11 to f/8). This is called *opening up.* When you set your lens to its widest aperture, it's called "wide open."

Each halving or doubling of the light represents one full stop. The same halving and doubling concept also applies to shutter speed and ISO. This relationship is an important aspect of the exposure triangle, as we shall soon see.

Don't worry if your head is now spinning after wading through those explanations. Mine did too, the first time I tried to understand how aperture works. I would start to understand what I was reading, only to have that understanding vanish as I got deeper into the information. That's normal, so keep rereading until it sinks in. You will find that as you apply and practice the technical tips given throughout this book, concepts like these will eventually become as familiar as the back of your hand. You may also be asking why you need to understand how f-numbers work. It is because you can control aperture size to create a variety of interesting and creative effects, which leads me to my next point.

The size of the aperture not only controls the amount of light let into the lens, but it also controls depth of field (DOF). *DOF* is the portion of your photograph that is in focus. Manipulating DOF can yield some very creative photos. You will notice that outside of your scene's DOF, objects become blurry. There are two creative uses of DOF: shallow DOF and deep DOF.

READ ME

Important note on fractional stops: Most modern DSLRs use 1/3 of a stop increments by default, and give you the option of 1/2 of a stop increments. Keep this in mind as you calculate a full stop. My DSLR gives both 1/3 and 1/2 of a stop options, and I choose to operate it in 1/3 of a stop increments. As I flip the dial, I know I have reached a full stop with every third click.

Shallow DOF

Shallow DOF is often used for portraits because it allows you to keep your subject clear and in focus while blurring the background. The blur softens and simplifies the background and isolates the subject, making her front and center. To achieve shallow DOF, make the aperture big. Depending on your lens, you can try anywhere from f/1.4 to f/5.6. Remember that a bigger aperture is represented by a smaller f-number.

Deep DOF

Deep DOF is often preferred for landscape photography because it allows the photographer to create shots that are in focus throughout. To achieve deep DOF, set your aperture to a smaller size (f/16 or smaller). Remember that a smaller aperture has a bigger f-number. Tip: Some DSLRs can stop down to f/32 or smaller. Be aware that something called "diffraction" can occur with these very tiny apertures. Diffraction actually causes blur.

Other Factors That Affect DOF

Besides aperture size, two other factors affect DOF. They are distance from your subject and focal length.

Distance from your subject » When you get closer to your subject, even if you have selected a smaller aperture (greater f-number), the DOF will decrease, meaning the area that is in focus will become smaller. If you move farther away from your subject, the DOF will become greater.

Focal length » *Focal length* is the length of your lens. A prime lens has a fixed focal length. Zoom lenses have a range of focal lengths. You zoom in to make the focal length longer, and zoom out to make it shorter. Shorter focal lengths will make the background clearer, while longer focal lengths will do just the opposite and make the background blurry. So if you want the background to be blurry, zoom in on your subject. If you want the background to be clearer, do the opposite and zoom out.

For bonus goodies and information on this book's e-companion, visit CreateMixedMedia.com/artofeverydayphotography.

13

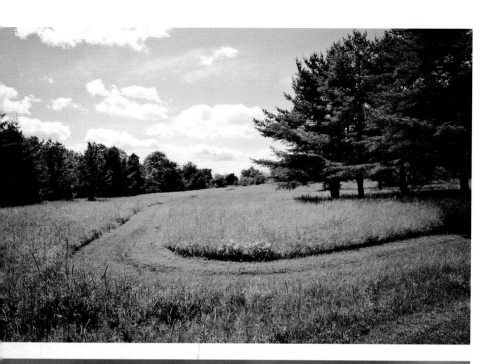

« This landscape photo is an example of deep DOF, where the scene is in focus from front to back. My goal was to create a wide-angle shot where the meandering path was in focus throughout. I snapped this photo using my 15–85mm f/3.5–5.6 lens with a small aperture setting of f/22 (for clarity from front to back) and a focal length of 15mm, which captures a nice wide-angle view of the scene.

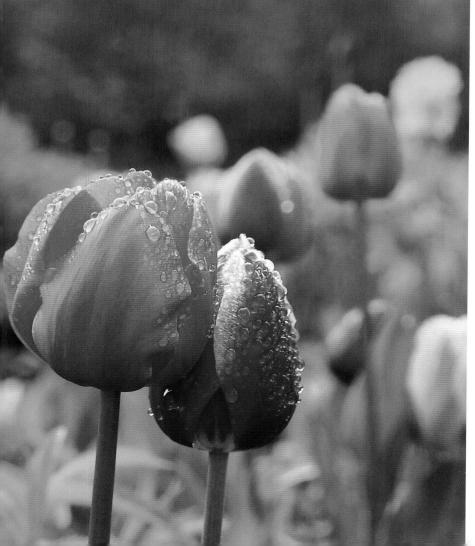

« This photograph is an example of shallow DOF, where the tulips in the foreground are crisp and clear, while the elements in the background are indistinct and blurred. I took this shot with my 15–85mm f/3.5–5.6 zoom lens, with an aperture setting of f/5.6 and a focal length of 40mm. I was relatively close to the tulips when I took the shot, which blurs the background more than if I were farther away.

⌃ Use your lens's sharpest aperture when the important elements in your scene are on the same plane; doing so will make these elements look tack-sharp. This photo was enhanced in Photoshop with an MCP Action.

The Sharpest Aperture

Most lenses are at their sharpest at either f/8 or f/11. This is called the "sweet spot" of the lens. If you want to discover your lens's sweet spot, a general rule of thumb is to *calculate two full stops down from wide open*. If your DSLR operates with fractional stops, you will need to keep that in mind as you calculate. So if your lens's widest aperture is f/2.8, its sweet spot aperture will be f/5.6. Use the sharpest aperture when the important elements in the scene are generally at the same focal distance (if they are on the same plane). This ensures that all the elements will be tack-sharp, as long as there is no camera shake, of course. Using your lens's sharpest aperture for scenes with depth, especially landscape shots with depth, will *not* be effective; instead use a smaller aperture (f/11–f/22) for decent overall sharpness.

Later on in the book I will provide you with some photo scenarios and the best aperture sizes to use with those scenarios.

For bonus goodies and information on this book's e-companion, visit CreateMixedMedia.com/artofeverydayphotography.

15

Shutter Speed

Shutter speed is the length of time that the shutter of your camera stays open when you are making a picture, allowing light to hit your camera's image sensor. It's also known as *exposure time.*

Faster shutter speeds keep the shutter open for a shorter amount of time and let in less light, while *slower shutter speeds keep the shutter open for a longer amount of time and let in more light*. Bright scenes call for faster shutter speeds; low-light scenes call for slower shutter speeds and often a tripod to prevent blur caused by camera shake.

Faster Shutter Speeds

Faster shutter speeds freeze motion. They come in handy for capturing crisp, clear sports shots; shooting portraits of a wiggly baby; capturing a splashing wave mid-air and seeing each water droplet and rivulet; or capturing every detail of a ballerina leaping.

Slower Shutter Speeds

Slower shutter speeds capture motion progression that is characterized by blur (also known as *implying motion*). They are used to create those smooth, dreamy, cotton-candy effects in waterfall shots; to capture the motion of a field of wildflowers blowing in the wind; to record the motion progression of people moving in an otherwise still scene; and for a special technique called panning, which we get into later. These are just a few possibilities. Note: Slower shutter speed shots, except for panning, require the use of a tripod to prevent blur caused by handheld camera shake.

Shutter speed is a lot easier to understand than aperture. It's measured in fractions of a second. If the speed is less than a second long, it will be expressed as a fraction; an example is 1/1000 of a second.

Here is a simple trick for decoding shutter speeds that are expressed as fractions. The bigger the number in the *denominator* of the fraction, the *faster* the shutter speed will be. So 1/1000 is a much faster shutter speed than 1/125.

Which shutter speeds are considered slow? Which are fast? Refer to the illustration of standard shutter speeds to help answer those questions. Later on in the book I will provide you with information on photo scenarios and the best shutter speeds to use with those scenarios. We'll also talk about at what point you need to use a tripod, as opposed to taking the shot handheld. Note: Many DSLRs have a Bulb shutter speed setting. Bulb allows you to keep the shutter open for as long as the shutter release is depressed. It's often used for photographing fireworks.

When you increase shutter speed by one full stop, say 1/125 to 1/250, you halve the amount of light that hits the image sensor. When you decrease shutter speed by one full stop, say 1/60 to 1/30, you double the amount of light that hits the image sensor. Note: Remember that modern DSLRs operate with fractional stops. This applies to shutter speed as well as aperture.

Slower Speed
(blurs motion)

Faster Speed
(freezes motion)

...1 1/2 1/4 1/8 1/15 1/30 1/60 1/125 1/250 1/500 1/1000...

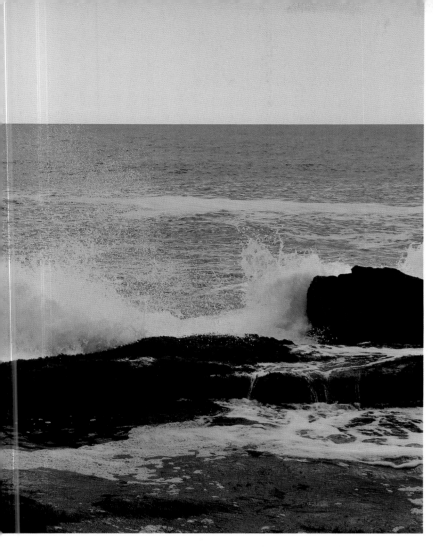

« I zoomed in and froze the motion of this wave with a very fast shutter speed of 1/1000 of a second. I am mesmerized by the reflections of the blue sky and clouds on the water. You can even see them in the puddles.

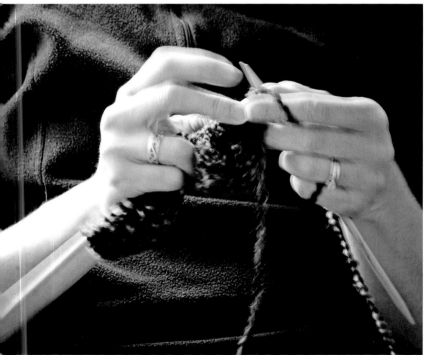

« I used my 100mm f/2.8 macro lens and a shutter speed of 1/4 sec. to capture the motion progression of my friend knitting. Because the shutter speed was too slow for a handheld shot, I used my trusty tripod.

ISO

Let's talk about *ISO* (International Organization for Standardization). ISO settings allow you to control your image sensor's sensitivity to light, and thus help you achieve proper exposure. In the olden days (ahem!), you could buy a role of film for your camera labeled with a certain ISO speed. I remember choosing film for my little Kodak 110 camera at the pharmacy: 100 for bright light outdoors and faster 400 film for the lower-light situations, oh, and don't forget the disposable flashcubes! (I loved the way they looked all cotton-candy-like after use.)

Today's DSLRs use ISO in the same fashion as their non-digital predecessors, only instead of using specialized film, we can flip our DSLR's dial to the desired ISO speed any time we wish. The basic rule of thumb is *choose a low ISO number for bright light situations, where your image sensor will be less sensitive to the light, and a higher ISO setting for low-light situations, to make your sensor more sensitive to the available light*. While it is important to keep the ISO as low as possible to avoid noise and poorer image quality, in low-light situations, without flash or a tripod, raising the ISO may be the only way to get the shot.

I left ISO for last because it's my least favorite part of the exposure triangle. I have a love/hate relationship with it. I love that it can increase my camera's sensitivity to light and give me the faster shutter speeds I need for taking handheld shots in low light. Sometimes I hate the unsightly side effect of a high ISO, which is graininess.

You see, higher ISO speeds (usually over 400) produce a noticeable graininess that is not apparent on the tiny LCD, but obvious when you view your photos on a monitor or in print. This is especially true with cropped-frame DSLRs. I struggle to keep ISO as low as possible at all times to avoid the grain. This noise is attractive only if you're going for an artistic grainy-film look. And yes, I do love it when that's what I'm aiming for. Otherwise, it is a rather annoying trade-off that can make a stunning capture not so special.

These days, the more-expensive full-frame DSLRs do have nongrainy, faster ISO speeds, but this can come at a cost. Many photographers report a decrease in contrast, color saturation and detail when they use very high ISO speeds.

My guess is that DSLR manufacturers will keep improving over the years where higher ISO side effects are concerned.

READ ME

Increasing ISO = makes your DSLR more sensitive to the light = which yields a faster shutter speed = which means you'll be able to take low-light shots handheld and prevent blur from both camera shake and subject movement. Yay! But, wait . . . the trade-off of a high ISO = graininess in less-expensive DSLRs and reduced image quality in nongrainy full-frame DSLRs.

ISO 100	**(bright, sunny outdoor daylight)**
ISO 200–400	**(overcast outdoor daylight, outdoor shade, indoors well-lit)**
ISO 800–1600+	**(low light, outdoors or indoors)**

Choose a low ISO number (slow speed) for bright-light situations, which will make your image sensor less sensitive to the light, and a higher ISO setting (faster speed) for low-light situations, to make your sensor more sensitive to the available light. Most DSLRs start to see graininess at ISO 400, which gets worse as you increase the ISO speed. Full-frame cameras will not see as much grain with faster ISO speeds.

Of course you don't want to miss important shots, so crank up the ISO if you need to. You can always convert the photos to black and white and embrace this effect, which creatively mimics film grain. Another trick I often use to cover up the grain is to add a subtle texture layer using Adobe Photoshop® Creative Suite® or Adobe Photoshop® Elements®. Or you can try performing noise reduction in Photoshop (CS or Elements). Topaz Labs offers a noise reduction plugin called Topaz DeNoise® made especially for Photoshop and Lightroom. This type of software allows you to perform noise reduction "surgery" on those shots where you just couldn't avoid the high ISO. Noise reduction software applications can be pretty amazing, but often have a loss in detail, so it's best to keep the ISO as low as possible in the first place. Here are some basic things to remember.

- ISO 100 is perfect for very sunny environments. It is also helpful for slow shutter speed exposures, as it makes your image sensor less sensitive to the light, allowing for properly exposed shots with slower shutter speeds. And you'll love it because it hardly produces any noise.

- ISO 200–400 works for overcast outdoor daylight, outdoor shade or indoors where the scene is bright.

- ISO 800 can sometimes be used in low-light situations (outdoors or indoors) without a flash. Mind the shutter speed—if it gets too slow for a handheld shot you can either increase ISO to make it faster, use a tripod to accommodate the slower shutter speed, or use flash. "What's too slow for a handheld shot?" you ask. We'll talk about that in Chapter Two.

- ISO speeds of 1600 or more are best for indoor and outdoor low-light situations without a flash. Beware though, as photos can become very grainy with these high ISOs. To avoid grain in low-light situations, you have a couple options. You can set the ISO low and mount your DSLR on a tripod to accommodate the slower shutter speed, or use flash with a lower ISO. You can always just crank the ISO baby (to increase shutter speed enough for a handheld shot without flash) and enjoy the creative grain!

READ ME

From this point on, I will give you what is called EXIF data, which stands for Exchangeable Image File Format, for most of the DSLR photographs in this book. I will include the lens type, focal length (the length of your lens, expressed in millimeters), ISO and aperture and shutter speed settings, as in this example: 15–85mm f/3.5–5.6 lens at 15mm, ISO 200, f/3.5 for 1/320 sec. Please note that all of my DSLR photographs in this book were shot with a cropped-frame Canon DSLR with a 1.6 crop factor. This will affect the way you interpret the focal length part of the EXIF data, so a 15mm focal length on a cropped-frame DSLR gives the same field of view (which is how much of the scene you can capture) as a 24mm focal length on a full-frame DSLR. I'll elaborate on this when we talk about lenses in this chapter.

For bonus goodies and information on this book's e-companion, visit CreateMixedMedia.com/artofeverydayphotography.

19

Final ISO Tips

Eventually you will want to move away from shooting with ISO Auto where the camera chooses an ISO setting for you. It doesn't know that you are trying to keep it low to avoid graininess and reduction in image quality. So be sure to set your ISO manually as soon as you feel ready to.

If photographing a static object in low light with a tripod, set the ISO as low as possible, which will result in minimal photo noise. Because the object is still, you can go with as slow a shutter speed as is necessary to accommodate the low ISO setting. If there is potential for movement with your subject, you can up the ISO some to make for a shorter exposure time, reducing the chances of subject blur.

Most modern DSLRs allow you to set a maximum ISO speed in ISO Auto mode (consult your DSLR instruction manual). If you set the maximum ISO speed to 400, your DSLR won't ever go above that speed when choosing exposure settings.

I am a huge fan of using natural light for my photography, but I have recently come to see how using a dedicated flash unit (instead of the built-in flash) in lower-light situations can actually look quite natural. I am not a fan of the camera's built-in flash, as it usually looks anything but natural and can cause red eye. We will be exploring flash possibilities later on, but I did want to emphasize that flash can help you avoid using a high ISO setting. Using a reflector (one of those white, silver or gold discs that come in a variety of sizes) can also help to keep ISO down.

Here it comes You took the words right out of my mouth Increasing ISO one full stop from say 100 to 200 doubles the sensor's sensitivity to light, just as decreasing it one full stop from say 400 to 200 halves it. Now we know that all three components of the exposure triangle—aperture, shutter speed and ISO—operate on this same principle. What significance does this have? Now it is time to find out.

The Halving and Doubling of Light Principle

Whether a full stop of light comes from aperture, shutter speed or ISO, it has the exact same effect on exposure. There are many different ways you can combine aperture, shutter speed and ISO settings to achieve the same overall exposure; however, each combination will achieve a different creative result. Here you will see two photographs of the same white flowers that I captured with my 50mm f/1.8 prime lens. The first shot was taken with a correct exposure of ISO 100, 1/2000 sec. at f/2. In the second shot, which has the same exposure as the first, I changed the aperture from f/2 to f/11 (I stopped down five full stops) and kept the ISO at 100. To maintain the same correct exposure, I needed to slow the shutter speed by five full stops, from 1/2000 sec. to 1/60 sec. Essentially I did an equal swap of stops. Even though both of these photos have the same exposure, they look very different, don't they? The photo with an aperture of f/2 has a shallow DOF, while the photo at f/11 has a greater DOF.

Understanding how stops work is essential to manually operating your camera, since you will be the one dialing in settings that yield proper exposure and help you to achieve your creative goals. However, you are never alone in picking your settings because you have a fantastic guide. That guide is called the light meter, which we will discuss next.

How Exposure Works With a Mobile Phone

I am definitely a fan of and active participant in mobile photography. I view the smartphone as a photographic tool and am constantly amazed by the ways in which mobile photographers use it to create stunning photos and art. Mobile devices do have their limitations. You cannot control shutter speed (the smartphone camera does it for you based on lighting conditions) and the aperture is fixed (depending on the model you have, usually f/2.4 or f/2.8). This can create challenges when it comes to achieving your creative goals; however, there are apps that can help you realize your creative intentions in the post-editing stage (e.g., you can mimic shallow DOF with an app like BlurFX).

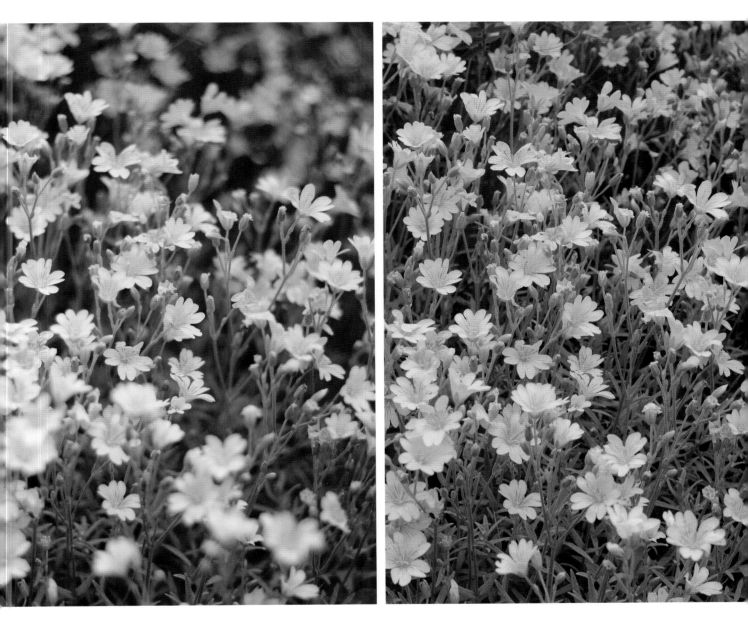

⌃ Even though both of these photos have the same exposure, they look very different, don't they? The photo with an aperture of f/2 (left) has a shallow DOF, while the photo at f/11 (right) has a greater DOF.

For bonus goodies and information on this book's e-companion, visit CreateMixedMedia.com/artofeverydayphotography.

21

The Light Meter

When you look inside your digital SLR's viewfinder or at its LCD screen, you see your camera's internal light meter. It is represented by a continuum that goes from -3 to +3 (some DSLRs have -2 to +2). Depending on your camera, you may see numbers or thick marks that represent the numbers. When the tracking marker hits the dead-center mark of 0, you have found a correct exposure.

To the left of 0 means underexposure (too dark), while to the right of 0 indicates overexposure (too bright). Each +/- number represents a full stop of light. Between the stops are dots or smaller dashes that represent 1/3-of-a-stop increments or 1/2-of-a-stop increments if you have set up your camera that way.

When you are in any exposure mode other than Manual mode and you point your lens at something and press the shutter release button down halfway, the internal light meter automatically evaluates the scene and the camera selects settings to bring the marker to 0.

If you are using Aperture Priority mode or Shutter Priority mode, your DSLR will let you know when it can't expose correctly for the setting you've selected in combination with the ISO setting and available light in the scene. It will blink until you choose a new setting that the camera can work with.

If you are shooting in Manual mode, you must dial in all settings yourself to bring the marker to 0.

When you are choosing aperture, shutter speed and ISO settings all on your own in Manual mode, use the internal light meter as your guide. Manipulate the settings until the marker underneath the continuum reaches 0. If you are way off the continuum, the marker will flash to guide you. If it flashes on the far left, you are underexposed and need to make adjustments accordingly; either choose a wider aperture, a slower shutter speed or higher ISO. If it flashes on the far right, you are overexposed and need to make adjustments accordingly; either choose a smaller aperture, a faster shutter speed or lower ISO. Be aware that you will not always be able to get a dead-center 0 reading in Manual mode, especially outdoors where light changes; even the slightest change can have an effect. The marker will bounce around above and below the center mark, but as long as it does not go beyond 2/3 of a stop in either direction, the exposure should be fine. Keep in mind that your evaluation of proper or correct exposure involves your personal taste and opinion—are you looking for more classical shots or something more creative like darker, moody photos that are a bit underexposed?

You've been absorbing quite a bit of information, so now it's time to get out and shoot. Next up are some simple photography tips and techniques that you can immediately start applying to achieve beautiful results.

-3..2..1..[0]..1..2..+3

0 on the light meter marks correct exposure. To the left of 0 means underexposure (too dark), while to the right indicates overexposure (too bright).

Susan's Top Tips for Making Awesome Photos Right Now

Tip 1: Shoot From the Gut

There is a lot of information to absorb in this book. For now I want you to not think, grab your camera and head out for a photowalk! Follow your instincts, let go, enjoy, get out of your head that tends to over-think if given the chance, and allow yourself to really start to see. Trust yourself and rely on your creative voice. I believe that a truly good photo has something precious about it that touches the viewer, something he knows and feels but may have a hard time putting into words. It emanates from the subject matter and the way in which the photographer sees the subject, and often has very little to do with the photographer's technical skill. While you are shooting pictures, at some point you feel this something special in your gut—it happens quickly—when you recognize beauty in an instant moment, and very swiftly, without much thought or planning, you click the shutter button as a feeling rises in your chest. And you know you have experienced and captured magic!

Tip 2: Use Natural Light If Possible

Your camera's built-in flash tends to give a harsh, unnatural-looking spotlight cast to photos. This is also true for the cellphone flash. Avoid using it and look for natural light instead.

Overcast light is soft and even and well suited for photographing things like close-ups of flowers and portraits. If it is bright and sunny and your subjects are squinting in the sun, consider heading to the edge of a shade tree to look for less harsh, more even light, but be sure to avoid the dappled sunlight look, unless it's for creative purposes.

The golden hours of early morning and late afternoon/early evening give a nice warm light to work with and can create a heavenly backlight for your subjects.

Not that I wish to give you the impression that flash is always bad. I myself have a dedicated external flash unit that can give very natural results, especially when it's powered down, diffused and used in conjunction with the available light in the scene. I often use it to fill in unpleasant shadows on faces and add pleasing catchlights to eyes. More on flash soon.

⌃ 24–70mm f/2.8 lens at 24mm, ISO 100, f/10 for 1/640 sec.

For bonus goodies and information on this book's e-companion, visit CreateMixedMedia.com/artofeverydayphotography.

23

Tip 3: Keep Still

Be sure to hold still when taking a photograph, to ensure the best possible focus. I recommend holding your arms in close to your body, breathing out slowly while snapping the photo.

Many DSLR lenses have an image stabilization feature that will help you get sharp photos in lower-light situations where your shutter speed is slower. (Do not use this feature when your DSLR is on a tripod, as it can actually damage your camera.)

Of course your DSLR does have handheld limits (which we'll discuss in Chapter Two), so you might have to use a tripod or monopod, especially in low-light situations where the shutter speed is slow.

To make sure you got a clear shot, view the photo in Playback mode and zoom in to see your subject. If it looks blurry, retake the photo.

For mobile devices, apps like Camera+, Top Camera and ProCamera have an image stabilization feature. Did you know you can turn an iPhone on its side and use the volume control button to take the picture? I find that this method promotes camera stability. Setting your phone on a tripod/monopod is another possibility. I own a Ped3 mount for my iPhone, which I attach to my regular DSLR tripod.

Tip 4: Change Your Vantage Point

Shoot up, down, sideways, look behind you. Try capturing the world from a vantage point other than your normal, everyday standing height; get down on the ground, lie on your back and aim your camera up at the tops of the trees. Get close to things and then get closer still, as long as you can find focus. Try tilting your camera and shooting at an angle. Instead of shooting a subject straight on, capture a side view, as this will add dimension to your photo. Shoot vertically and horizontally and leave some room for cropping. If you want to emphasize height, shoot vertically. If you want to emphasize width, shoot horizontally. Explore the possibilities and take your time.

《 15–85mm f/3.5–5.6 lens at 15mm, ISO 200, f/9 for 1/200 sec.

Tip 5: Look for Clean Backgrounds

It's easier than you may think to become so enamored with your subject, you forget all about the background. Be sure to look for simple, clean backgrounds devoid of distracting elements. This does not mean your background needs to be sparse—just no intruders (those random elements that have nothing to with the shot).

Darker objects and shadows in the background that you see in your camera's viewfinder look worse in actual photos, so try to avoid including them in the shot. If you are experienced with Photoshop (CS or Elements), it is possible to use the Clone Stamp tool or Spot Healing Brush tool to get rid of some unwanted pixels, but it is much easier to get a clean shot in the first place.

Tip 6: Frame Your Scene

Look for naturally occurring borders with which to frame your scene. Branches of trees make excellent natural borders for your photos. Another technique is to fill the frame with your subject, so that it is front and center and there are no other distracting, unwanted elements to take away from it.

《 15–85mm f/3.5–5.6 lens at 50mm, ISO 100, f/5.6 for 1/400 sec.

Tip 7: Pick a File Format to Stick With

Let's talk about shooting in RAW versus using your DSLR's highest-quality JPG setting. There are pros and cons for each.

If you shoot in RAW, you'll notice that the photos come out of the camera looking pretty plain. That's because your DSLR leaves it completely up to you to manipulate things like color saturation, contrast and sharpness in the post-editing stage in a program that supports RAW format, like Adobe Photoshop® Lightroom® or Adobe Camera Raw®, which is accessible through Photoshop CS and Photoshop Elements.

Be aware that shooting in RAW takes up a lot of memory. When you shoot in JPG format, files come out of the camera looking much more spiffy than their RAW counterparts because your camera has already enhanced them a bit for you. You can then take these JPG files into editing programs like Photoshop CS/Photoshop Elements or Lightroom to tweak them even further and/or add creative effects.

RAW allows for a bit more control in the editing stage, especially when it comes to things like changing the white balance setting after the fact and removing noise/graininess from your photos. So if you have the time to process the RAW image files, and the room on your computer, go for it! If not, the highest-quality JPGs are more than sufficient.

Note: I access the latest Photoshop CS tools through Adobe Photoshop® Creative Cloud® (referred to as Adobe CC). It has a new Camera Raw filter that will allow you to alter any file type. It doesn't replace the capability of Adobe Camera Raw but definitely gives you more editing options all in one place.

Tip 8: Don't Miss the Shot

Use Continuous Shooting mode, also referred to as Burst mode, to take photos of a single short event. That way one of the shots is bound to be just right.

One morning I was on a photowalk and noticed that a pack of pigeons kept alighting from their spot on a building roof, flying around the building, coming to rest on the roof again. I made sure my camera was set to Continuous Shooting mode and snapped away. I chose the best shot from the bunch.

If you are shooting mobile, the iPhone 5s and iOS7 operating systems (which are current as I write this) allow for Burst mode shooting with the native camera, and apps Camera+ and Camera Awesome have a Burst mode setting.

Tip 9: Capture Symmetry, Pattern and Repetition

These compositional components will create a sense of balance, organization and rhythm in your photographs. Look for them in architecture, as well as in environments where they naturally occur. Symmetry with a focal point draws the eye to the subject and gives the photo a sense of balance.

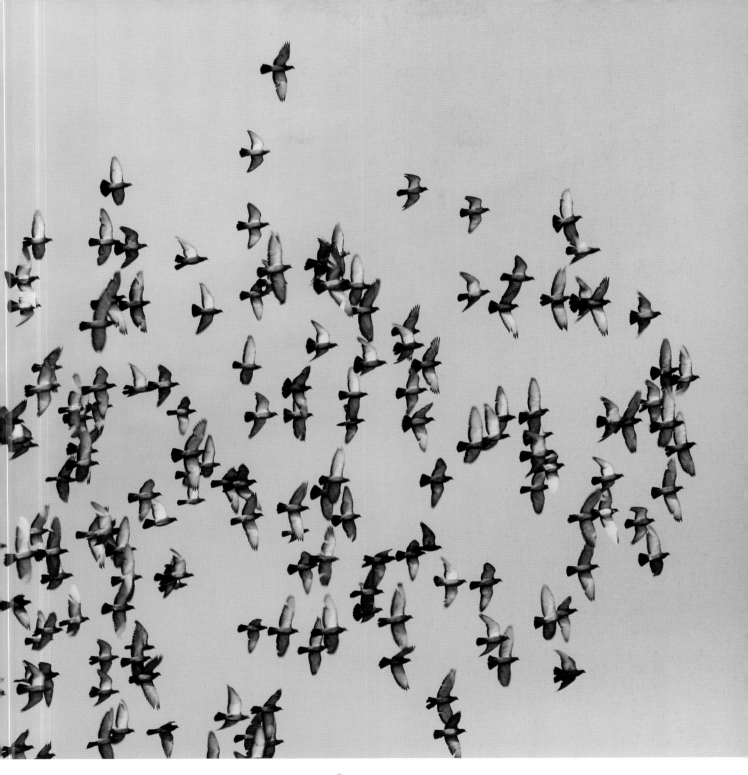

⋙ 15–85mm f/3.5–5.6 lens at 70mm, ISO 200, f/13 for 1/320 sec.

For bonus goodies and information on this book's e-companion, visit CreateMixedMedia.com/artofeverydayphotography.

27

Tip 10: Avoid Putting Subjects Dead-Center

Photos are usually more interesting when your subject is off to one side in your capture. Using the rule of thirds can help you implement this tip. To apply it, imagine placing a tic-tac-toe board evenly over your scene. Place your subject on one of the four intersections for the greatest visual impact. Most DSLRs, as well as the iPhone native camera and various camera apps, have a grid display feature to help in composing your shot.

Tip 11: Decide Where to Put the Focus

Scenes often have two subjects, one in the foreground and the other in the background. Use your creative instincts to determine which one should get more visual weight and put the focus on that subject, leaving the other one a dreamy blur. Zooming in with a tele-photo lens can help you achieve this creative result as will increasing the distance between the two subjects.

《 15–85mm f/3.5–5.6 lens at 85mm, ISO 200, f/9 for 1/250 sec.

Tip 12: Keep Horizons Straight

This can be a hard task, and one that I never seem to get spot on with my camera alone. You can use your DSLR's grid feature and align the horizon with one of the horizontal lines. Another possibility is to purchase a special level that attaches to your camera's hot shoe, located on the top of your camera.

If all else fails, you can rotate your photograph in Photoshop in the post-editing stage. For mobile devices, the iPhone native camera as well as the camera apps Camera+, 645 PRO, Pure and 6×6 have a built-in grid feature. If you need to rotate your mobile photo, you can use an app like Pho-toWizard or Perspective Correct.

》 15–85mm f/3.5–5.6 lens at 85mm, ISO 200, f/7.1 for 1/500 sec.

⌃ A CameraBag filter has been applied to this iPhone photo.

All About Lenses

Shopping for lenses can be a daunting task at first. I'm here to demystify the process and help you select the types of lenses that will best suit your photography needs. Some lenses are ideal for landscape photography, while others make great portrait lenses. Many are versatile and can meet a wide range of needs.

I'll start off with an important tip. I recommend buying a camera body only, as opposed to a DSLR that comes with a standard kit lens. The kit lens is a general-purpose lens, not of the highest quality. My first DSLR came with a kit lens. Once I purchased higher-quality lenses, it took up permanent residence in the back of a drawer. Don't make the same mistake. Save those pennies and put them towards better lenses that are a good fit for your photography needs—save up for some "good glass" (gotta love photography street talk).

For bonus goodies and information on this book's e-companion, visit CreateMixedMedia.com/artofeverydayphotography.

29

Focal Length Defined

To understand the variety of lenses, it is important to understand focal length. *Focal length* is the distance, measured in millimeters (mm), from the glass of the lens to the image sensor, where the image is formed. It determines the field of view, which in plain English means how much of the scene your lens is capable of recording. For instance, a wide-angle lens (35mm or shorter) can capture an expansive view of a landscape.

Lens Types

Prime

Prime lenses have a fixed focal length and do not zoom in or out. These lenses tend to be sharper than zoom lenses because there is less glass and hardware between the subject you wish to photograph and your camera's image sensor.

Zoom

Zoom lenses offer versatility. You can zoom in (increasing focal length) to achieve a narrow field of view or zoom out (decreasing focal length) for a wider field of view. (My Canon 24–70 mm f/2.8 zoom lens actually has a reverse zoom, where the lens barrel gets longer as it zooms toward its shortest focal length.) Zoom lenses work well for portrait photography because you can zoom in very close to subjects without having to be physically close to them. These lenses are also a good choice for sports and wildlife photography. Some zoom lenses have a fixed maximum aperture that you can access at any focal length. Others have a variable maximum aperture, where the maximum aperture size becomes smaller as you zoom in. If you have the money, lenses with a wide fixed maximum aperture tend to be preferable (e.g., 24–70mm f/2.8 lens), as you can access this maximum aperture at every focal length, which allows for beautiful shallow DOF no matter the focal length and lets more light hit the image sensor in low-light situations, which means you get faster shutter speeds in low light. I own a 15–85mm f/3.5–5.6 lens that has a variable maximum aperture. I love the expansive focal length range I have access to (wide angle to medium telephoto), but I'm sometimes frustrated in lower-light situations because I don't have access to a wide aperture at every focal length, which in turn forces me to up my ISO to obtain a faster shutter speed. Tip: If you are interested in a super-long telephoto zoom lens (300mm+), you'll notice they are quite pricey. A cheaper alternative is to purchase a teleconverter or extender, which attaches to your medium or long telephoto lens and magnifies it.

Wide-Angle

Wide-angle lenses record a wide-angle view of the scene and are great for landscape photography. A fisheye lens is an example of a super-wide-angle lens that distorts your photo, curving it for a cool effect.

Macro

Macro lenses allow you to shoot subjects extremely close-up. If your budget will not allow for a dedicated macro lens, you can purchase special macro extension tubes that attach to your regular lens and increase magnification. (A true macro lens will do a better job, but the tubes will definitely make a difference.) I use my 100mm f/2.8 dedicated macro lens for macro photography and sometimes as a general-purpose or portrait lens. Its wide aperture capability lends a nice blurred background to my portraiture work.

Fast

What does it mean to be a fast lens? Prime lenses that have a wide maximum aperture or zoom lenses that have a wide fixed maximum aperture that's available at every focal length (like f/2.8) are known as *fast lenses*. That is because these wider apertures let in more light, therefore allowing for faster shutter speeds; thus the name fast lens. They are especially useful in low-light situations.

Focal Length Ranges

Wide-angle focal lengths are 35mm or shorter. The shorter the focal length, the wider the field of view will be.

Standard focal lengths (50–60mm) are natural-looking and equivalent to what the eye sees. This range works well for street photography.

Telephoto focal lengths are generally 85mm+. Keep in mind that camera shake is a side effect of telephoto lenses and can often lead to blurry pictures. I'll give you some tips to help with that later in the book.

Important note: The focal lengths aforementioned are for a full-frame DSLR. To determine equivalent focal lengths for a cropped-frame DSLR, you have to divide by your lens's crop factor. So a 50mm focal length on a cropped-frame DSLR with a crop factor of 1.6 would actually have the same field of view as an 80mm focal length on a full-frame camera. Here's the math: 80mm divided by 1.6 = 50mm. Please note that all focal length suggestions given in this book are for full-frame DSLRs. If you have a cropped-frame DSLR, you will have to divide by your camera's crop factor to determine equivalent focal length. If you don't know what your cropped-frame camera's crop factor is, do a good ol' Google search.

Protecting Your Lenses

- Be sure to change your lenses out in a relatively dust-free setting. Do not hold the camera on its back when you change the lens, as it exposes the delicate innards to particles floating in the air, which can collect on the image sensor and eventually affect image quality.

- You can protect the glass of your lens with a UV filter, so if you drop it, the UV lens takes the beating instead of your pricey glass. Some photographers choose not to use it, because it is yet another piece of glass between the scene and the image sensor, which could affect image quality. I myself usually put a hood on my lens to cut down on glare, and I find it also does an excellent job of protecting my lens.

Mobile Device Lenses

A variety of lenses available on the market are made specifically for your mobile phone or mobile tablet. You can often find telephoto zoom, wide-angle, fisheye and macro lenses in the form of a lens kit—multiple lenses all in one. Although they can't achieve the same level of quality as your DSLR lenses, they certainly broaden what you can achieve with your smartphone camera. Olloclip, Photojojo, iPro lens and Sony make attachable mobile phone lenses.

For bonus goodies and information on this book's e-companion, visit CreateMixedMedia.com/artofeverydayphotography.

31

Scene Modes

Your DSLR's Scene modes are a positive first leap away from full Auto mode. They do give you some control, as they allow you to inform the camera of your creative wishes so that it can choose settings accordingly. Scene modes do have their limitations, however. You can't override the camera's setting choices when you use them (for example, you can't increase shutter speed in a low-light scene), it is impossible to control ISO and white balance, and the built-in flash will fire when the shutter speed slows, whether you want it to or not. Below are the most common Scene modes.

⌃ Some of the most common DSLR Scene modes include Portrait, Landscape and Close-up/Macro modes.

Scene Modes

Portrait

Portrait mode tells the camera that you are taking a snapshot of a person. It reacts by choosing a wide aperture, which gives your image a shallow DOF. The result will be a clear subject set against a nicely blurred background.

Landscape

Landscape mode informs the camera that you will be photographing an expansive landscape and that it should choose a smaller aperture to achieve clarity from front to back in the scene. You may need a tripod, as smaller apertures yield slower shutter speeds.

Close-Up/Macro

Close-Up/Macro mode is ideal for photographing flowers or any kind of object up close. It works especially well with telephoto zoom lenses, as you can zoom in on your subject to make it look a bit larger.

Sports

Select Sports mode when you wish to freeze a moving subject. The camera chooses a faster shutter speed to help prevent blur in the shot. This mode works best in bright light.

Night Portrait/Night

Night Portrait mode/Night mode will select a slower shutter speed to let in enough natural light to expose the low-light shot. You will most likely need a tripod for this mode. The built-in flash may fire to get a correct exposure of a subject that the camera assumes is in the foreground.

Program AE (Automatic Exposure) Mode

Using Program AE (Automatic Exposure) mode, known as P mode, is another step towards taking more creative control of your camera. In this mode you allow your camera to set both the aperture and shutter speed to yield a correctly exposed photo, which it will do most of the time, especially in bright even light and in scenes where there is no heavy contrast between light and dark areas. While your DSLR is busy worrying about exposure, you can take the time to learn about some of your camera's other amazing features, like the metering modes, exposure compensation, white balance, adjusting ISO manually, the autofocus modes and manual focusing, and AF point selection. You can focus on composition techniques and play with and come to understand how light works.

The neat thing about P mode is that you can override your camera's setting choices at any time using a program shift feature (consult your DSLR instruction manual for specifics). Let's say that you wish to freeze motion and you know you will need a faster shutter speed than what the camera is indicating. It's time to swap stops or fractions of stops—just flip the dial to the right to increase shutter speed, and the camera will widen the aperture accordingly. Increasing ISO speed will also increase shutter speed. Tip: In P mode, the built-in flash will not automatically fire, so you get to decide when you want it to flash. That's good news for your photos.

P mode can be very useful when you don't have time to fuss with your camera settings and need to take spontaneous photos. I am a fan of using this mode for street photography as I never know when that photographic moment will present itself as I stroll along, and I must be ready for it. Also, as you walk about the streets, the light changes, sometimes drastically, so allowing the camera full control in this situation is not a bad idea. There is always a chance that the shutter speed will get too slow for a handheld shot. So you either have to keep an eye on the ISO or set it to a faster speed initially.

Let's dig right into Chapter Two, where we discover some more camera features you can explore while in P mode.

« I spent the morning at a coffee shop, my camera on the table within arm's reach, set to P mode and at the ready to shoot any interesting passersby. That's how I got this spontaneous shot of those quintessential Maine mud boots paired with a fancy outfit. I knew the shutter speed would be slow in this low-light situation, so I rested my elbows on the table to stabilize my camera. 75–300mm f/4–5.6 lens at 75mm, ISO 800, f/4 for 1/32 sec.

For bonus goodies and information on this book's e-companion, visit CreateMixedMedia.com/artofeverydayphotography.

33

Taking
CREATIVE CONTROL
of Your Digital SLR

> I was born with music in my soul. I learned to play the flute, working hard to technically master the instrument, so that I could give a voice to the music inside of me. I was also born with a passion to see, to keenly take notice of the beauty around me and in other people. My camera is now the instrument I strive to master, a tool through which I can attempt to share with you the world not only through my eyes, but through my heart.

» Susan Tuttle

I am willing to bet you are already seeing some improvement in your photographs and beginning to feel empowered by the creative control that comes with learning the technical aspects of your DSLR. Are you ready to gain even more creative control now that you've got a taste of what it feels like to be in the driver's seat?

It's time to teach you about exposure compensation and the metering modes—both of which come in handy when dealing with exposure problems. We'll also explore light: the best light for photographs, types of light and tricks for manipulating light that is less than perfect. I give lots of information on how to achieve tack-sharp photos in any light.

You'll unfurl your artistic photography wings further as we fully explore our DSLR's semiautomatic exposure modes: Aperture Priority mode and Shutter Priority mode. This study naturally progresses to a place where you can comfortably take full control of the reins in Manual mode, and it's easier than you may think if you have mastered the other modes.

Metering Modes and Exposure Compensation

In Chapter One I gave you an overview of your camera's light meter—how it functions and how you can use it in Manual mode to guide you in choosing settings that will yield a correct exposure.

Now that you are gaining more control of your DSLR by utilizing the Scene modes and P mode, it's time to expand our discussion of the light meter.

Metering Modes

How does the camera evaluate the scene and determine a proper exposure? It uses what are called the Metering modes, also known as the Light Metering modes.

Evaluative Metering (Matrix Metering)

DSLRs are set to this mode by default and it's used most of the time. The camera evaluates the entire scene and picks an exposure that will work well. It will link to any AF (autofocus) point you choose.

Partial Metering/Spot Metering

These modes are useful when you want the camera to accurately expose one part of a scene. Let's say you are taking a photo of someone with rich, golden backlighting behind her. If you use Evaluative Metering mode, the camera will evaluate the entire scene and most likely darken the subject's face. If you use either Partial Metering mode or Spot Metering mode, the camera will take its reading from the subject and maintain correct exposure of the subject despite the backlighting. Tips: (1) Spot Metering mode gives a bit more control than Partial Metering mode. (2) Some DSLR's Spot/Partial metering modes function only at the center of the viewfinder. For those DSLRs (which include the less pricey Canons), you will either have to use these modes with the center AF (autofocus) point or utilize the AE lock button to lock exposure while using an AF point other than the center one. If using Manual mode, you will have to meter using the center of your viewfinder. All Nikons and pricey Canons can spot meter off any AF point. Sound Greek? No worries, as we'll discuss AF points and AE lock later in this chapter.

Center-Weighted Average Metering

This mode is a combination of Evaluative and Partial/Spot Metering modes and is the least used. It evaluates the entire scene, giving priority to the frame's center.

For bonus goodies and information on this book's e-companion, visit CreateMixedMedia.com/artofeverydayphotography.

35

<< This photo was taken during the evening, with rich, golden natural backlighting and subtle top lighting. Spot metering was used to ensure that the subject's face would be properly exposed despite the backlighting. 15–85mm f/3.5–5.6 lens at 67mm, ISO 200, f/5.6 for 1/60 sec.

Exposure Compensation

Your camera's internal light meter is not perfect—exposure compensation to the rescue!

Your DSLR's internal light meter is calibrated to measure reflected light as opposed to the actual light that falls on the scene (called incident light). It is programmed to average out the light and dark tones in your scene and give you an average reading of 18 percent gray. This creates a well-exposed photo most of the time, except in cases where you have either a lot of white tones in the scene or a lot of black tones. In these cases, the camera will still average the tones out to 18 percent gray.

What does this look like in your photos? In scenes with a lot of black, the black tones will look dark gray. In scenes with a lot of white, the white tones will look gray. These toning problems can easily be corrected with *exposure compensation*—overriding the camera's setting selections to either increase or decrease your exposure.

If you choose the exposure compensation feature and turn the dial to the right, you increase exposure. If you turn the dial to the left, you decrease exposure. Note that exposure compensation can be used only in P mode, Aperture Priority mode and Shutter Priority mode. (In Manual mode, you decrease or increase exposure by dialing in settings for aperture, shutter speed and ISO.)

A general rule of thumb in using exposure compensation: For scenes with a lot of black tones, decrease exposure by one to two full stops. For scenes with a lot of white tones, increase exposure by one to two full stops.

In this snow scene there is obviously a preponderance of white. In averaging out these tones to 18 percent gray, my camera indicated a "correct" exposure, which you can see turned out rather gray. I used exposure compensation to increase exposure by two full stops, which resulted in the bright white snow that I saw with my naked eye.

For bonus goodies and information on this book's e-companion, visit CreateMixedMedia.com/artofeverydayphotography.

37

Light

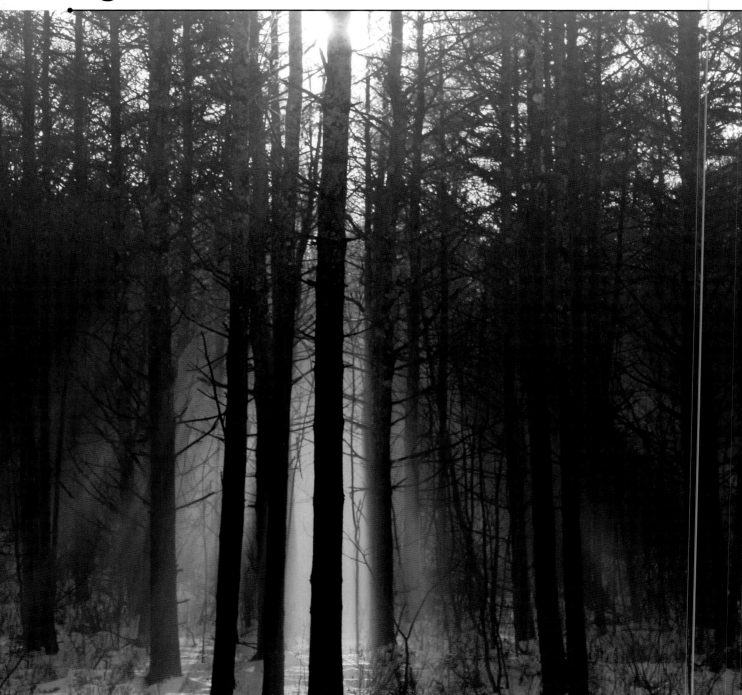

⌃ The best times of day to make photos are during the golden hours, which are roughly one hour after sunrise and one hour before sunset. This photograph was taken in winter during the hour before sunset. The fog rising above the snow is illuminated by the sun that is low in the sky. 15–85mm f/3.5–5.6 lens at 50mm, ISO 200, f/10 for 1/80 sec.

> You've gotta taste the light, like my friend and fellow shooter Chip Maury says. And when you see light like this, trust me, it's like a strawberry sundae with sprinkles.
> » Joe McNally

The golden hours, also known as the magic hours, are considered to be the best light for photography and occur roughly an hour after sunrise and an hour before sunset. This type of light is soft and casts glowing golden hues on all it touches.

The sky tends to be clearer at these times of day, making for sharper photographs. Because the sun is lower, shadows become softer and longer and quite interesting. Some landscape photographers shoot only during the golden hours, as it's most flattering for their work. When the sun is closer to the horizon, you can make wonderful use of side lighting, backlighting and front lighting, all of which we will discuss here.

When it comes to available natural light, it is best to search for the most ideal lighting situations, but sometimes that's not possible. I'll give you tips for shooting in any kind of light.

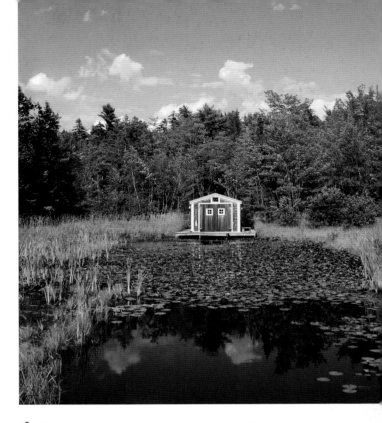

⌃ Late afternoon front lighting casts even illumination over this scene, making for a pleasing shot that is devoid of harsh shadows. My wide-angle lens perspective, coupled with the reflections in the pond, give depth to an otherwise flat-looking scene. 15–85mm f/3.5–5.6 lens at 19mm, ISO 200, f/14 for 1/160 sec.

Types of Light

Soft Light and Hard Light

Soft light (such as golden hour light) is a photographer's favorite. It is diffuse, indirect, devoid of harsh shadows and contains mostly midtones that create soft edges. It's ideal for portraiture as it softens the appearance of wrinkles, blemishes and shadows under the eyes. If soft light is not available, move your subject to the shade or manipulate hard light with special tools like diffusers and reflectors.

Hard light is direct, harsh and contrasty, with very bright highlights and dark, well-defined shadows. Midday full sun is an example of hard light. Hard light is difficult to work with, although it can be used for dramatic, creative effects. (More on shooting in full-sun is available in the e-companion to this book. See CreateMixedMedia.com /artofeverydayphotography to find out more.)

Tips: First, no matter the kind of light, each light source has a direction. The part of your subject that is closest to the light will be highlighted, while the far side will be in shadow. So make sure your focal point is well lit. Second, eyes naturally go to the brightest point in a scene, so put your subject there.

Front Lighting

Front lighting occurs when the sun is low in the sky and hits your subject straight on. This type of light is even, soft and works well for portraits, as the shadows fall behind the subject, leaving her face smooth and youthful-looking. Front-lit scenes can look rather flat, as shadows are what create depth and dimension. For this reason, be careful when using it for landscape photos, as depth is what makes landscape shots interesting.

For bonus goodies and information on this book's e-companion, visit CreateMixedMedia.com/artofeverydayphotography.

39

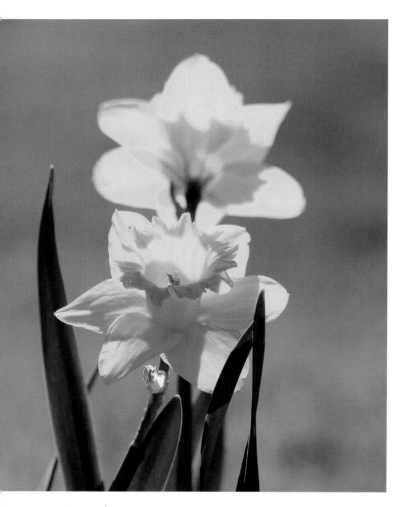

⌃ Golden hour evening light illuminates the semitransparent petals of the flowers in my garden, giving them a magical glow. 75–300mm f/4–5.6 lens at 155mm, ISO 100, f/5.6 for 1/400 sec.

Backlighting

Backlighting can be accessed during the golden hours when the sun is low in the sky. It falls behind your subject and hits the photographer's face. These types of scenes contain mostly highlights and shadows with very few midtones in between.

The highlights are present behind the subject and create pleasing rims of glowing light, a halo effect around the head, while the subject's face is often cast in shadow, sometimes deep shadow.

These deep shadows make for wonderful silhouette effects. If you don't want a silhouette effect and wish to illuminate the subject's face, you can use spot metering or use exposure compensation to increase exposure by a full stop or two. Fill flash is also an option. I often use backlighting for golden hour shots in my garden. The backlight illuminates the semitransparent petals of my flowers, giving them a magical glow.

Another creative effect you can achieve by shooting into the sun is lens flare—a great example of where "wrong" can feel very right. Lens flares have interesting colors, often in delicious violet tones, and to me they spell pure dreamy. Higher-end lenses have special coatings that reduce lens flare, so your best bet for capturing wild and colorful ones is to use a less-expensive lens. My 50mm f/1.8 lens does a fabulous job of capturing strong flares that contain red, yellow, violet and sometimes prism-like effects. If you don't want lens flare, attach a lens hood.

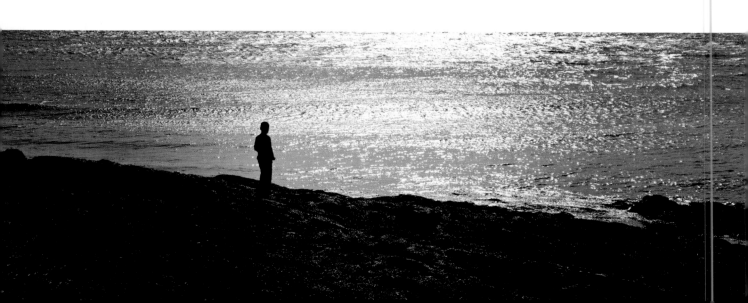

⌃ Shooting into the sun can create artistic lens flare effects around your subjects, and my 50mm prime lens does a particularly great job of it. The lens flare in this photo enhances a special moment between father and daughter. I used Spot Metering mode to ensure a good exposure of the subjects' faces despite the backlighting. I took the shot with a wide-open aperture to create an ultrasoft background covered in bokeh. 50mm f/1.8 lens, ISO 100, f/1.8 for 1/1,000 sec.

《 Backlit scenes can leave elements in the foreground in deep shadow, creating a soulful, mysterious silhouette effect. 15–85mm f/3.5–5.6 lens at 35mm, ISO 200, f/16 for 1/400 sec.

For bonus goodies and information on this book's e-companion, visit CreateMixedMedia.com/artofeverydayphotography.

41

In this photograph, side lighting from a north-facing window illuminates the front of the subject and gradually fades into long shadows. This makes for a dramatic shot. 15–85mm f/3.5–5.6 lens at 59mm, ISO 800, f/5 for 1/40 sec.

Side Lighting

Side lighting spells drama. Photographs that utilize side lighting will make your viewer go "Oooo!" When your subject is hit from the side with light, his features will become more defined, revealing every little detail, which in some portraiture cases can be unflattering. Parts of your subject will be well-lit, while other areas will fade into long shadows.

This is one of my favorite types of light to work with, especially with portraits of children, as their youthful, perfect skin and wide eyes look fantastic in just about any kind of light.

If you find that the side lighting is too harsh, you can use fill flash to fill in the shadows, preferably from a diffused external flash unit, which will give you more natural results. A reflector is another possibility—just bounce light onto your subject's face to fill in some of the shadows.

⌄ Midday, partly sunny, cloud-filled skies act as a massive reflector and offer perfect even light for photographs. 15–85mm f/3.5–5.6 lens at 15mm, ISO 100, f/16 for 1/200 sec.

Top Lighting

Top lighting illuminates your subject from above, and occurs when the sun is high in the sky (midday). When the sun is bright, harsh shadows will fall downward on your subject. If this subject is a person, you won't like the results; let's just say he will look as if he hasn't slept in a while.

Solutions are to use fill flash or a reflector to cast light onto the face (position the reflector under the chin), place a diffuser disc over the head to block out the sun, or simply head to the shade (just at the edge of the shade produces more pleasing results than deep shade).

If the sky is overcast, top lighting will cast a nice, even, soft light on your subject. You might still need the reflector to soften under-eye shadows. I often head out into the garden to photograph my flowers in overcast light.

When shooting scenes with overcast skies, try to leave out as much of the sky as possible, unless you are aiming for a when-wrong-is-oh-so-right creative result.

For bonus goodies and information on this book's e-companion, visit CreateMixedMedia.com/artofeverydayphotography.

43

Indoor Light

When taking photos indoors, natural light is preferable. Place your subject near a brightly lit window, north-facing being most preferable for a soft, diffused light.

If the light source is too harsh, use a sheer curtain to diffuse it. If you encounter a low-light situation indoors, there are a number of things you can do to get a well-exposed, clear shot.

Reflectors allow you to bounce light onto your subject and fill in shadows. You have the option to use a slower shutter speed in conjunction with a tripod; we'll discuss minimum shutter speeds for handheld shots very soon, so hold tight. Set the ISO to 100 when using the tripod, to achieve the best image quality, unless you are taking a portrait and there's a chance for subject movement. In that case, select a faster ISO speed, which in turn will give you the faster shutter speed you need to prevent subject blur.

When using a tripod, also be sure to use the timer or a shutter release cable or wireless remote, so that you don't have to touch the camera to take the shot, which can cause blur. If you don't have a tripod, a last resort is to crank up the ISO, making your DSLR more sensitive to the available light and unfortunately also reducing image quality.

Note: There can be multiple sources of light in your scene at one time. Multiple light sources often make the most delicious shots!

Bounce Flash - This indoor photo was made using available light from a bright window and illumination from a diffused Canon Speedlite 580EX II flash unit being bounced off a white ceiling. 50mm f/1.8 lens, ISO 400, f/2.2 for 1/200 sec.

My friend and photographer Crystal Sullivan and I teamed up to make some portraits of her beautiful babe. We placed him near a fairly bright window, Crystal used a reflector to bounce light onto the shadows on the right side of his body, and I made lots of baby cooing sounds while shooting in Burst mode to ensure I got a few good captures. I used Spot Metering mode to correctly expose his face and to maintain a black background. (This is an alternative to using exposure compensation to capture true black tones in your photos.) Crystal and I did not want to use flash with such a young child and knew the low light would call for a slower shutter speed (especially because I kept ISO at 400), so I had to press the shutter button when the baby was completely still, to avoid subject blur. Using Continuous Shooting (Burst) mode gave me more nonblurry pictures to choose from. 15–85mm f/3.5–5.6 lens at 31mm, ISO 400, f/4.5 for 1/80 sec.

What About Flash?

As you have probably gathered by now, I am not a big fan of the camera's built-in flash, as its hard, direct light can overly brighten subjects while darkening the background, and cause red eye. One of the few scenarios where I have seen the built-in flash look natural is when it is used in the bright light of day as a fill flash, to brighten dark shadows on the subject.

Most current DSLRs allow you to control the power of the built-in flash's output up to a point, but with an external flash unit you get even more control, not only with controlling flash output but in manipulating the direction and angle of the flash head. This control yields more natural-looking photos. I am a fan of external flash units and use mine in low-light situations and to help correct lighting problems I encounter while working with the different types of light aforementioned. You can attach this kind of flash to your camera's hot shoe, or remove it and attach it to a flash sync cord, which allows you more flexibility (some DSLRs have wireless capability).

Use external flash in one of two ways when it comes to low light and correcting lighting problems: (1) as a bounce flash or (2) as a fill flash.

Bounce flash is a technique generally used indoors, where you bounce the flash off a white ceiling. The ceiling acts as a reflector, casting even light all around your scene and softening shadows behind the subject. The external flash can point up to the ceiling, or can be rotated at a variety of angles, so that you can bounce light off various locations (including reflectors and white walls). High ceilings will not work, as the distance is too far away to achieve illumination. Stick to white ceilings (or white walls), as any other color will cast its hue onto your photo.

Use fill flash to brighten (fill in) dark shadows. You can use your DSLR's wireless capability (or use a flash sync cord), which allows you to take your external flash off the camera and handhold it, pointing it at the darker areas of the scene that need brightening. An off-camera flash is also useful for creating directional light (like creating side lighting to add more depth and dimension to a shot).

Flash Tips

- Try powering down your dedicated flash by a full stop, take a test shot and further adjust the output of the flash as needed. You want the flash to blend in with the available light, not overpower it.

- You can soften the effect of your dedicated flash by using an attachable diffuser. This is highly recommended, but keep in mind they are only effective when there's something for the light to bounce off of, like a wall or reflector.

 Diffusers come in two styles: diffuser caps (called diffuser domes) that fit over your flash and softbox-style diffusers. I, myself, use a dome.

- To illuminate your subject sufficiently, don't stand farther than ten feet away from your subject, especially when using a flash with a diffuser.

 On the flip side, you don't want to stand too close either, as the result will be too harsh. A good range is four to ten feet away.

 There is a little trick that photographers use if they want the flash to "reach" farther. They increase ISO. One must give credit where it is due: I picked up that trick from one of Scott Kelby's books (which by the way, I highly recommend).

- The iPhone 5s (which is the newest iPhone as I type this) has a "true tone flash" that has a white LED flash and amber-colored flash that fire together at different strengths, depending on the color temperature of the scene. This feature will give your iPhone flash photography photos a more natural look.

Interested in some mobile apps that will enhance your smartphone's low-light performance? Check out these three: NightCap, 645Pro, AvgNiteCam

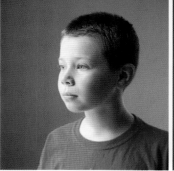
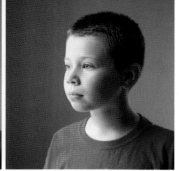

⌃ Take a look at the effect each of these standard white balance settings has on the same photograph. 50mm f/1.8 lens, ISO 400, f/1.8 for 1/200 sec.

White Balance

Light sources have different temperatures, whether warm or cool, and some can add unnatural-looking color casts to your photos. For example, have you ever taken a picture indoors under incandescent bulb lighting and noticed that the resulting photo had a yellowish cast? Or maybe you've taken a photo in the shade and the coloring came out much cooler than you expected.

Your DSLR has a variety of white balance settings that you can use to counteract these color casts and achieve color balance. Essentially, a white balance setting defines what the color white looks like in the given scene, which also affects the toning of all the hues in the scene.

With AWB, or automatic white balance, you allow your camera to evaluate the lighting and adjust the toning automatically. This auto mode works well most of the time, but for more creative control, I recommend making the white balance choices yourself.

READ ME

If you shoot in RAW, you can change the white balance setting after you have taken the photograph by using editing software like Photoshop.

If you shoot in JPG format, you do not have the same option, but can achieve similar results with Photoshop by adding a warming or cooling filter. Go to Layer> New Adjustment Layer> Photo Filter.

If you use Photoshop through Adobe Creative Cloud, it has a new Camera RAW filter that will allow you to alter any file type, including making white balance adjustments.

Daylight
This setting works best in outdoor, well-lit scenarios.

Shade
Shade adds a warmer cast to those shady, cool photos.

Cloudy
The Cloudy setting will add a warm tone—a bit less warm than Shade.

Tungsten
Tungsten counteracts the yellow cast of an incandescent bulb by adding a cool tone.

Fluorescent
Fluorescent counteracts the greenish tones produced by this type of light.

Flash
This warms the icy cold blue from a flash.

Custom
Custom allows you to create your own customized white balance setting for a specific light source. Basically, you take a photo of a white object in the setting you will be shooting in. Follow the directions in your DSLR instruction manual for taking the data from this shot and importing it as a custom white balance setting.

For bonus goodies and information on this book's e-companion, visit CreateMixedMedia.com/artofeverydayphotography.

47

Achieving Clear Focus and Sharp Photos

When we make photographs we aim not only for correct exposure but also the clearest, sharpest photos possible, unless of course we are embracing the blur for creative reasons. How many times have you captured a favorite shot that looked clear in Playback mode on the little LCD screen, only to find it was blurry when you saw it on the big screen? It happens to everyone, even professionals. The following tips and techniques will help you achieve tack-sharp photos of which you can be proud.

The Autofocus Modes

One Shot and Continuous

In Program AE (P) mode, Aperture Priority mode, Shutter Priority mode and Manual mode you can utilize your camera's Autofocus (AF) modes to help you achieve tack-sharp photos. (Full Auto mode and the Scene modes have built-in focusing protocols.) There are basically two AF modes, also referred to as drive modes: One Shot and Continuous.

Canons have three AF modes: One Shot mode (AF-S for Nikon); AI Servo mode, which is its continuous Focus mode (AF-C for Nikon); and AI Focus mode.

Use One Shot focus mode for shooting a still subject; press the shutter release button halfway down to lock focus (your camera will beep and show a focus confirmation light when it has locked focus), then press the button all the way to take the shot. If you have a moving subject, set your camera to Continuous Focus mode and it will continually focus as your subject moves around.

AI Focus mode for Canon is really like One Shot mode with an automatic sensor that allows it to go into AI Servo (Continuous Focus) mode when it detects motion. Use AI Focus mode when you are not sure whether to choose One Shot or Continuous Focus mode.

In some instances, manual focusing is your best choice. I use manual focusing for taking close-up shots with my dedicated macro lens, as it often has trouble honing in and locking focus on my subject in Autofocus mode. I just set my lens to manual focus and twist the focus ring until I find good focus on my subject.

Other situations where the camera will have a hard time finding focus on its own are with low-contrast subjects, subjects in low light, objects that are highly reflective, subjects with extreme backlighting, objects with repetitive patterns, and instances where you have both a near and a far subject.

Aside from special situations like these, I'm a fan of using autofocus over manual focusing because it tends to be more accurate.

Tack-Sharp Close-up - Use One Shot focus mode with the center autofocus point for shooting a still subject. The center AF point is the most sensitive. 100mm f/2.8 macro lens, ISO 100, f/5.6 for 1/400 sec.

⌃ Tack-Sharp Landscape - Forest landscapes are tough to photograph because the ground is usually covered with natural debris that distracts the eye. Snow-covered forests, on the other hand, are just perfect, and the clean backdrop makes the stark, crisp trees stand out. I further sharpened the trees with Photoshop's Sharpen tool. 15–85mm f/3.5–5.6 lens at 17mm, ISO 400, f/11 for 1/100 sec.

AF (Autofocus) Point Selection

When you look through your camera's viewfinder, you will see an array of focus points. The center focus point—the most sensitive point—should be pointed straight at your subject. In One Shot focus mode, press the shutter button halfway down to lock focus on your subject, then while the button is depressed halfway you can recompose your shot if you want (the subject does not have to be in the dead center of your composition), then take the photograph by pressing the shutter button all the way down. Pressing the shutter button halfway down also locks exposure settings on my Canon when I use Evaluative Metering mode in conjunction with P mode or the semiautomatic modes. Check your DSLR instruction manual for your camera's specifics.

Recomposing the shot is referred to as *lock focus/recompose*. If your subject is way off center, you'll get a clearer shot if you select an off-center AF point that lines up with your subject.

If you have a subject that is moving all about your scene, your best bet is to choose the All autofocus points option and let the camera automatically choose the best autofocus point, or choose Continuous focus mode. Some higher-end DSLRs actually allow you to use more than one AF point at a time.

If taking a landscape shot that has a lot of depth, the general rule of thumb is to focus 1/3 of the way into the scene for the best results. For portraits, focus the camera on the person's eyes. If one eye is closer to you, focus on that eye.

READ ME

DO NOT use the lock focus/recompose method if you are shooting with a very shallow DOF, as your subject will probably not stay in focus. Instead, choose an AF point that's closest to your subject.

For bonus goodies and information on this book's e-companion, visit CreateMixedMedia.com/artofeverydayphotography.

49

⌃ LockFocus Recompose - The lock focus/recompose technique comes in handy when you don't want your subject to be dead center in the photo. I didn't use a shallow DOF here, so I felt safe making such a significant recomposition. I was pretty confident the subject would remain in focus. I might have been safer choosing an AF point closer to the gull, but sometimes I like to live on the edge. 15–85mm f/3.5–5.6 lens at 85mm, ISO 100, f/11 for 1/250 sec.

How to Focus a Mobile Device

I would be remiss if I did not include information on how to focus your smartphone's camera. It's very simple. The native iPhone camera will automatically focus in the center of the screen, and will properly expose and apply a white balance setting for this area. If you wish to place the focus elsewhere in the scene, just tap the screen over your subject and the focus will relocate to that spot. The camera will adjust exposure and white balance for the new focus area. If there is more than one subject to focus on, like two faces, the camera will detect this and automatically create two focus points, one over each face. The camera apps Camera+, PowerCam and 645 Pro Mk II function a little differently, as they allow you to separate focus from exposure if you wish. Meaning, you can focus on one area, but set exposure from another (like the AE lock feature on your DSLR, which we'll discuss). Each camera app works a bit differently, so familiarize yourself with how focus and exposure work in your camera apps.

Stillness, Posture and Minimum Shutter Speed

It is very important to hold still when snapping the shutter release button on your DSLR, especially when the shutter speed is on the slower side, as even the smallest camera shake can yield a soft or blurry photo.

I often hold my elbows in close and breathe out slowly when I shoot. If I'm using a longer, heavy lens like my 24–70mm f/2.8 lens, I place my left hand under the lens barrel for added support. Having good posture can also help you make tack-sharp photos. I draw on aspects of my correct flute-playing posture (yep, I'm a flutist), my choral teaching skills for a good singing posture and yoga skills, which all call for a comfortable stance with feet shoulder-width apart and knees that are not locked.

I stand tall, imagining there is a string being pulled upward through the center of my head. I don't recommend leaning forward, as it will cause strain on the neck and shoulders, which can also cause problems with the wrist/hand, as everything is connected. Sometimes leaning forward is unavoidable, but be mindful of it.

If I need to be in a lower position, I step forward a bit with one leg and bend my knees slightly—a little bit like doing a lunge—or I go all the way down on one knee, always keeping a straight back. If I need to go lower still, I get down on my belly.

Why am I so mindful of shooting with good posture? I have caused injury to my body over time due to a poor flute-playing posture when I was younger combined with overuse of tendons/muscles. I want to help you prevent injury, avoid fatigue in the field that can lead to blurry photos, and help you get the sharpest photos possible.

If you know the shutter speed will be too slow for a handheld shot, look for a support (like a table) or use a monopod or tripod.

So how exactly does one know at which point the shutter speed is too slow for a handheld shot? There is a rule of thumb regarding minimum shutter speed, but before I share it, know that it is a rough guideline. I say that because

>> Tack-Sharp Portrait - Focus on the subject's eyes, whether a human or a pet. If one eye is closer to you, focus on it. I don't recommend using too wide an aperture with a close-up portrait (no wider than f/2.8), as some facial features might become blurred, unless of course you want that look for creative reasons, which I definitely do at times. This photo was taken by pet photographer Lara Blair. View more of her amazing work in the e-companion to this book. Visit CreateMixedMedia.com/artofeverydayphotography to learn more. 24–70mm f/2.8 lens at 45mm, ISO 200, f/11 for 1/125 sec.

I take handheld shots that are well beyond what I should be able to do according to this guideline.

It all depends on your body positioning and your ability to hold still, but even those who can hold very still have their limits.

The minimum shutter speed is the slowest possible speed with which you can safely take a handheld shot. Anything slower would require the use of a monopod or tripod. Basically, you need a support if your shutter speed is slower than your camera's 35mm-equivalent focal length. In plain English, let's say you are using a 50mm prime lens on a full-frame, 35mm-equivalent DSLR. That would mean your minimum shutter speed for a handheld shot would be 1/50 of a second.

What if you have a cropped-frame camera? Easy. Just multiply by your camera's crop factor to determine the minimum shutter speed. So for a 50mm lens on a cropped-frame DSLR with a 1.6 crop factor, your minimum shutter speed would be 1/80 of a second, because $50 \times 1.6 = 80$. What if your calculations produce a nonexistent shutter speed? Easy, just round up to the next closest speed.

On Subject Blur

There is another thing to consider when it comes to avoiding blur in your photographs, and that is what you are photographing. If you are photographing an inanimate subject with a low ISO, slow shutter speed and a tripod, you won't have any trouble getting a sharp photo. What if you are taking a portrait with a low ISO, slower shutter speed and a tripod? Using slower shutter speeds with portraits can be tricky, especially if the speed is slower than 1/60 sec. And by the way, I don't recommend doing that unless flash is involved.

To avoid subject blur with a shutter speed on the slower side, your subject needs to stay still. If there's potential for movement, bump up your ISO to get a faster shutter speed that will shorten exposure time. We'll go over ideal shutter speeds for many scenarios when we discuss the semiautomatic exposure modes (coming up in just a few pages).

Some lenses have an image stabilization feature that you can activate with the flip of a switch (called vibration reduction in Nikons). This feature can allow you to take handheld shots at slower shutter speeds; photographers claim this feature allows them to go two to four stops more before having to use a tripod (and yes, I can attest to that).

Tips: Do not use this feature when you place your camera on a tripod, as it can damage the mechanisms of the camera. Also, make sure it's turned off for shots with faster shutter speeds, as it will slow down the autofocus speed and potentially make your images less sharp.

Lock your DSLR's mirror in its up position, called mirror lockup. This makes a small difference, but increases the chances of sharper photos when used along with other tricks.

If the weather is chilly, dress warmly and wear fingerless gloves. No need for camera shake due to a shivering body and chattering teeth.

The iPhone 5s (which is current as I write this) has a new image stabilization feature, where the native camera quickly takes four shots in a row and merges them into one, reducing the chance of blur. Apps with image stabilization features include Camera+ and ProCamera.

Mobile device camera apps with self-timers include Camera+, Camera!, 645Pro, Pure and ProCamera. Attach your phone to a special mount that then connects to your DSLR's tripod or monopod.

The Lens Can Make All the Difference

In low-light situations a fast lens can make all the difference. I tend to grab my 50mm f/1.8 prime lens (50mm f/1.4 is preferable, but more costly). It's an affordable fast lens with a wide maximum aperture that can let in more light than a typical zoom lens, which allows for taking photos with faster shutter speeds (thus the moniker "fast lens").

A faster shutter speed prevents blur, plain and simple, whether it be subject blur or blur from camera shake. A faster shutter speed can help you avoid using flash and can also prevent you from having to bump up the ISO too high. The wide apertures you can access on a fast lens give a lovely, soft background, but I caution you to be careful when using its wider apertures, which create intensely shallow depth of field (DOF).

If you are taking a close-up shot of a person at f/1.8, you will get some features out of focus. On the flip side, if you are using an aperture smaller than f/22 on any lens, you can also cause blur; this phenomenon is known as *diffraction*. Lenses tend to be blurriest at their widest and smallest apertures.

Remember the rule of thumb that lenses tend to be at their sharpest two stops down from their widest aperture. Your lens's sharpest setting is best used when the elements in the scene are at the same focal distance (on the same plane). Using your lens's sharpest aperture for scenes with depth, especially landscape shots with depth, will not be effective; instead use a smaller aperture (f/11–f/22) for decent overall sharpness.

Let's say you have a low-light situation and you do not have a particularly fast lens or a tripod. What to do to get a clear shot? You need a fast shutter speed. Get it by using the widest aperture available and bumping up your ISO.

Tips for Clear Shots

- I recommend setting your DSLR to Continuous Shooting mode (Burst mode) and taking lots of photos of any one scenario. This will ensure getting at least one that turns out. For mobile devices, iPhone 5 and up has a Burst mode feature that you can access through the native camera. The apps Camera Awesome and Camera+ have Burst mode capability.

- Try back-button focusing. I cannot begin to express how much I love this feature! With this setting engaged, your DSLR allows you to lock focus with a button on the back of your camera and use the shutter release button to just shoot. This way you can avoid having to press the shutter halfway down to lock focus before taking the shot. And you don't have to refocus every time you let go of the shutter. I have wrist and hand problems that can be exacerbated by too much button pressing, so this helps me go a little easier on the buttons, preventing fatigue. I mentioned before that your DSLR's instruction manual may be confusing at times. I learned back-button focusing quickly from a YouTube video.

- Use Playback mode to check your shots. You'll have to zoom in to see if focus was achieved, as it is too hard to tell on the tiny LCD screen. I often head into a shady spot to check, because the screen is hard to see in the bright light of day (or get a snap-on LCD cover—like a mini awning for your screen). If the shot is blurry, try taking it again with a faster shutter speed or mount your DSLR on a tripod.

- Use your camera's Live View feature to check focus. This feature functions best when using a tripod and taking shots of still subjects; it allows you to see the scene on your LCD screen before you shoot, as opposed to looking through the viewfinder. Zoom in to check focus. Keep in mind this feature uses up battery power quickly.

- You can sharpen photos in software like Photoshop (CS or Elements).

For bonus goodies and information on this book's e-companion, visit CreateMixedMedia.com/artofeverydayphotography.

53

Semiautomatic Exposure Modes: Aperture Priority and Shutter Priority

When you are ready to take more creative control of your camera, it is time to explore the semiautomatic exposure modes, which are Aperture Priority mode and Shutter Priority mode.

In *Aperture Priority* mode (A or AV on your DSLR dial, depending on the make of your camera), you set the aperture while your DSLR sets the shutter speed based on the ISO setting, in an effort to yield a well-exposed photo.

In *Shutter Priority* mode (S or TV on your DSLR dial, depending on the make of your camera), you set the shutter speed while the camera sets the aperture size based on the ISO setting, in an effort to create a well-exposed photo. Which mode should you use? That depends on your creative goal and sometimes even on personal preference.

If you wish to control DOF, the area of the photograph that is in focus, choose Aperture Priority mode.

If you want to freeze motion, capture motion progression (referred to as implying motion) or experiment with a special technique called panning (which we'll talk about soon), you should choose Shutter Priority mode.

You will most likely find yourself shooting with Aperture Priority mode most of the time. Some professional photographers use it all of the time because DOF is of utmost importance to them, even when they are dealing with scenarios where shutter speed is also important (they just keep a close eye on the shutter speed).

These semiauto modes are easiest to use either in overcast daylight or with front lighting during the morning or evening golden hours, as these types of light are soft and even, making it easy to achieve correct exposure.

Always be mindful of your minimum shutter speed and know when it's time to use camera supports for longer exposures. For a refresher on minimum shutter speed, refer back to Achieving Clear Focus and Sharp Photos previously in this chapter.

As you use each of these semiauto modes and make setting selections, notice what your camera chooses for the other setting. This will help you understand how aperture and shutter speed settings work together to achieve proper exposure, and will make dialing in those settings all by yourself in Manual mode a snap.

You will notice larger apertures yield faster shutter speeds, while smaller apertures yield slower shutter speeds. You will also want to continue to use and master all of the tools/functions you practiced while in P mode like the metering modes, exposure compensation, white balance, AF modes, etc. I must emphasize the importance of *you* controlling ISO to avoid the visible graininess associated with higher ISO settings.

If you do choose to use auto ISO, just keep an eye on it to make sure it doesn't get too high. If it does, choose a lower ISO. If the shutter speed gets too slow for a handheld shot, use a support like a tripod. If you don't have a tripod, go ahead and use the higher ISO to make a handheld shot possible.

Most DSLRs allow you to set a maximum ISO speed in ISO Auto mode (consult your DSLR instruction manual). So if you set the maximum ISO speed to 400, your DSLR won't ever go above that.

I don't mean to give the impression that using one of the priority modes is as simple as choosing one setting, allowing the camera to choose the other and snapping away without a worry or care in the world, never checking your settings again. Remember, your DSLR does not have a brain, doesn't know what your creative goals are and only cares about achieving a proper exposure, no matter the cost. Here's a little scenario that will show you what I'm talking about and how you can apply some of the information I just tossed at you in the last few paragraphs.

Scenario: Let's say you're taking an outdoor portrait using Aperture Priority mode. The sky is blue and bright, with a few big puffy clouds floating around. You head out to the edge of shade with your subject, choosing f/5.6 to blur the background and an ISO speed of 200, which can work well in shade.

Just as you're about to trip the shutter, one of those big clouds covers up the sun, reducing the available light. You notice your shutter speed is now too slow for a handheld shot. What do you do to get the faster shutter speed you need while you're still in Aperture Priority mode?

To get the faster shutter speed you need more light. To do that you can choose a wider aperture if possible or raise the ISO.

Doing these things indirectly increases shutter speed, and a combination of the two in low-light situations can be effective. Always attempt to set the ISO as low as possible at all times to keep the noise level low. All of this goes to show that if you're in the driver's seat and you know what you're doing, you can have full manual control of your camera even when you're in one of the priority modes. Your DSLR is a tool, plain and simple. You're learning how to control it so you can use it to realize your creative vision. When things get sticky with exposure, some folks prefer to go into full Manual mode to directly control all settings, a valid choice for sure, but there's definitely more than one way to skin a cat.

Aperture Priority Mode

Choose Aperture Priority mode when you want to control depth of field (DOF), the portion of your photograph that is clear and in focus.

If you are taking a portrait or still-life photo and wish to have a clear subject in the foreground and a nicely blurred background, you want shallow DOF, which is achieved with a wide aperture (low f-number).

If you are taking a landscape shot and wish to have clarity from foreground to background, you want deep DOF, which is achieved with a small aperture (greater f-number). Let's say all of the elements in your scene are more or less the same focal distance from you and you want them all in sharp focus. Then it's best to choose your DSLR's sharpest aperture, its sweet spot, generally two full stops down from wide open.

OK, quiz time. Do you remember the other two factors that affect DOF? If you answered distance from your subject and focal length, you would be correct. The closer you are to your subject, the shallower the DOF will be, and conversely, the farther away you are from your subject, the greater the DOF will be.

Shorter focal lengths will make the background clearer, while longer ones will make the background more blurry. For a review on aperture and DOF, please refer to the Exposure's Magic Three section in Chapter One.

DOF Preview Button

With shallow DOF, you will want to pay close attention to focus. If you're taking a portrait with shallow DOF, make sure you focus on the eyes. For still-life scenes, focus on the object or portion of the object you wish to be clear. You can use Playback mode (zooming in to check the outcome) and retake the photo if necessary, or you can use your DSLR's handy-dandy DOF preview button.

I am about to share something very important, so be sure to read the next two sentences carefully. *When you look through your viewfinder, no matter the aperture setting, your DSLR will always display the image as it appears through a wide-open aperture.* That is because the lens stays fully open at its widest aperture and does not physically move to the indicated setting size until you snap the shutter release button.

For bonus goodies and information on this book's e-companion, visit CreateMixedMedia.com/artofeverydayphotography.

55

This is why the DOF preview button is so helpful. When you depress it and look through the viewfinder or on the LCD screen in Live View mode, you will see what the actual photo will look like at the aperture you have chosen. Be aware that the DOF preview button will darken the scene in the viewfinder but not in the actual photograph. It will not darken the scene in Live View mode, but the trade-off is that Live View will suck up your battery life.

Aperture Setting Ranges

Portraits and Still-Life Shots With Shallow DOF

Roughly f/4 or wider is a good bet for achieving a soft, blurry background.

Be careful when using very wide apertures for portraits, as the extremely shallow DOF can cause some of the facial features to be blurred, especially at close range. I generally don't go wider than f/2.8 with portraits for that very reason, unless I want creative blur. Also, avoid using the lock focus/recompose technique with wider apertures because it can lead to blur in your subject. Instead, choose the focus point closest to your subject.

Portraits and Still-Life Shots With Greater DOF

Generally f/5.6 to f/11 is a good range. With these aperture settings, you can capture some of the detail in the background. For group shots use a range of f/8 to f/11

to ensure that all people in the scene are in focus, especially if you have staggering and tiers. For photos where the subjects are on the same plane, use your lens's sweet spot setting for tack-sharp focus.

Landscapes

Most landscape scenes call for deep DOF where there is clarity from front to back in the scene. A general range of f/11 to f/22 is preferable, with the smaller apertures producing the most clarity from front to back. If you are focusing on a subject in the foreground and want to maintain detail in the background, I recommend using f/18 or f/22. F/16 is also fine if you need to keep the shutter speed from slowing too much.

Higher than f/22 can lead to diffraction, which causes blur. Be aware that using these smaller apertures will mean a slower shutter speed for your camera in order to have enough light to achieve correct exposure. Bring along the tripod just in case, especially during the golden hours, when light is not as bright. If you don't have your tripod with you and must shoot handheld, it's time to do some stop swapping in order to get that faster shutter speed. Just enlarge the aperture or increase the ISO to indirectly increase shutter speed. A combination of the two can also be effective.

Macro Shots

Depending on the style of your close-up (whether it be more like a miniature landscape scene or a still-life/portrait), you'll want either greater or shallower DOF. If you want clarity from front to back in your mini-landscape scene, go with a smaller aperture. Note that you will most likely need a tripod or even an external or ring flash (donut-shaped attachable flash unit) to accommodate the smaller aperture. If the macro shot is more like a portrait or still-life scene where you want detail in the background to be blurred, use a wider aperture. Draw from the ranges aforementioned.

« Shallow DOF: I captured this moment of my friend and me toasting against a beautiful sunset while camping with our families on Moosehead Lake in Maine. The aperture is set to wide open, creating extremely shallow DOF. 50mm f/1.8 lens, ISO 100, f/1.8 for 1/160 sec.

⌃ Deep DOF: Hiking to the top of Mount Kineo in Maine offers a stunning, rewarding view. I wanted to capture the girls looking out over the landscape, getting an appreciation for how far they had climbed. To ensure clarity in the scene throughout, I used a small aperture. I bumped up the ISO to keep the shutter speed fast enough to prevent blur, as it was a bit windy up there. Remember that shutter speed slows when you use smaller apertures to allow more light in to correctly expose the photo. 15–85mm f/3.5–5.6 lens at 50mm, ISO 400, f/16 for 1/250 sec.

Shutter Priority Mode

Shutter Priority mode is a good choice when your priority is motion related, whether you want to freeze motion, capture motion progression (implying motion) or use the panning technique where you pan the camera along, level with your moving subject as you take the shot with a slow shutter speed. Important consideration: What happens if you are in Shutter Priority mode and you wish to manipulate aperture? You can indirectly do so by manipulating ISO; increasing ISO yields a smaller aperture, while decreasing it yields a wider aperture.

Here's another scenario to help demonstrate: Imagine you are photographing a child's birthday party in late afternoon golden light. The children are jumping up and down on a trampoline bathed in soft, golden front lighting. Behind them is an incredible view of staggered mountains. In Shutter Priority mode you select a fast shutter speed of 1/500 sec. to freeze the fast action jumping and an ISO of 200, which is appropriate for the light in the

scene. The faster shutter speed automatically generates a wider aperture that blurs the mountains in the background. You want to capture the detail of the mountains in the background and know you need a smaller aperture to do it. How can you get the smaller aperture while maintaining the faster shutter speed for freezing motion? Easy, just increase ISO.

Freezing Motion

If freezing motion is your aim, you will need a shutter speed of 1/250 sec. or faster. Your speed selection would depend on the type of action you are trying to capture. General rules of thumb: The faster the action, the faster the shutter speed needs to be to freeze the motion. Moving in close to your subject, whether you are zooming in with a telephoto lens or physically moving in closer, will require a faster shutter speed than if you are farther away or zooming out.

For bonus goodies and information on this book's e-companion, visit CreateMixedMedia.com/artofeverydayphotography.

57

⌃ Freezing Motion - Watching my daughter run and leap through a field of buttercups with flowers in hand melts a mother's heart. I always wish for her to feel this free. To freeze this moment in time, I set my shutter speed to 1/400 sec. while in Shutter Priority mode. 15–85mm f/3.5–5.6 lens at 35mm, ISO 400, f/10 for 1/400 sec.

Shutter Speed Ranges for Freezing Motion

- When taking photos of completely still subjects, you might be able to get away with 1/60 sec. Use a tripod if this pushes you over your handheld limit. With subjects who are relatively still and if you want to be on the safer side, a range of 1/125 sec. to 1/250 sec. is plenty fast for achieving a sharp image, with 1/250 sec. ensuring better clarity. To obtain a faster shutter speed in low light, use a wide aperture or increase ISO or use a combination of the two. Flash is always an option if you can't make it work.

- Fast action shots require 1/500 sec. and sometimes faster, depending on how fast the subject/object is moving and your distance from it.

Helpful Tips for Freezing Motion

- If in doubt, increase the shutter speed. In Shutter Priority mode, the camera will adjust the aperture size accordingly to achieve correct exposure. If there's not enough light, you can always increase the ISO setting or use flash.

- Take sample shots to find an appropriate shutter speed. Look at the samples in Playback mode, zooming in to check for clarity. Adjust shutter speed if necessary and retake the photo.

- I once saw a teaching video of photography guru Bryan Peterson demonstrating that you rarely need a shutter speed that's faster than 1/500 sec. to freeze people in fast motion. In fact, there was a time when cameras couldn't obtain a shutter speed any faster than 1/1000 sec., and they were still able to freeze fast action.

- Use Continuous Focus mode so that your camera continually focuses on your moving subject, or pre-focus your camera in the area of the frame that you expect your moving subject to be in when you take the shot.

- Shooting in Continuous Shooting mode (Burst mode) will help ensure that you get at least one awesome shot!

- Turn off image stabilization when using faster shutter speeds, as it can actually slow down your camera's auto-focus mechanism. Reserve image stabilization for slow shutter speed scenarios, especially when there is low light.

Implying Motion and Creative Blur

Very slow shutter speeds can capture motion progression characterized by blur. Photographers often refer to this as *implying motion*. This technique can yield creative shots like the classic, cottony-dreamy blurred waterfall shot, or a capture of commuters in a train station at rush hour where the moving people are blurred and the backdrop of the station is clear and in focus. You might want to use it to photograph a crisp, in-focus subject set against a moving object like a child looking up at a spinning carnival ride. If you want to get really creative, you can imply motion with a still object, where it looks as if the object is actually moving. All of these types of creative shots require slow shutter speeds of 1/60 sec. or slower and a tripod is a must.

Suggested Slow Shutter Speeds

How slow you are able to make your shutter speed is directly dependent on how bright the scene is and what your aperture and ISO settings are. (The very small apertures and a low ISO will allow for longer shutter speeds.)

The lower the light, the slower the shutter speed you will be able to obtain. If the scene is too bright, you can darken the lens with an ND filter so less light will hit your image sensor, allowing for the slower shutter speed (more details on ND filters coming right up).

Don't feel locked in by the slow shutter speed suggestions below. Experiment to find your own preferences, in conjunction with what the ambient light (available light) in your scene will allow. Your distance from the subject also makes a difference. The closer you are to your subject, whether you are zooming in or physically moving closer, the blurrier the subject will be.

- cotton-candy-like waterfall: 1/2 sec. to 5 sec.
- blurred field of tall grass blowing in the wind: try 1/2 sec.
- lightning: use the bulb setting for as many seconds as necessary (anywhere from 4 to 30 sec.)
- fireworks: 2 to 6 sec.
- lit-up spinning amusement park ride at night: 1 to 3 sec.
- automobile light trails on a highway at night: 8 to 20 sec.

- blurred moving train against still, waiting passengers on a platform: 1/10 to 1/30 sec.
- people walking or ice-skating: 1/4 sec. to 1 sec. (If the shutter speed is very slow, around 15 seconds or more, you won't even see the moving people in the resulting image.)

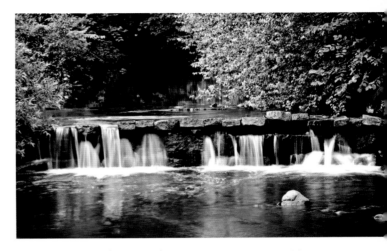

⌃ Implying Motion - I'm always on the lookout for pretty waterfalls, and I don't think I'll ever tire of those timeless, dreamy, cotton-candy-like captures of them. I made this shot with a slow shutter speed, using a bridge railing as a support, and used my camera's self-timer to avoid shaking the camera by pressing the button myself. In Aperture Priority mode, I set the ISO to 100 so the image sensor would be less sensitive to the light, chose a small aperture of f/22, and since the environment was pretty bright I attached a 0.6 neutral density (ND) filter to my lens to reduce the amount of light passing through it, allowing for the slower shutter speed. You can certainly use Shutter Priority mode with these types of shots and experiment with different shutter speed settings. (If the camera can't handle the slower shutter speed you selected, it will blink to let you know.) You can also take slow shutter speed shots in Manual mode, and I'll show you how when we get to that point in the book. 15–85mm f/3.5–5.6 lens at 85mm, ISO 100, f/22 for 0.6 sec.

For bonus goodies and information on this book's e-companion, visit CreateMixedMedia.com/artofeverydayphotography.

59

Creative Blur in a Nutshell

• A tripod is a must in preventing the shake that occurs when taking a long exposure shot. Use a shutter release cable, wireless remote release or your camera's self-timer to take the shot, avoiding vibration caused by depressing the button yourself.

• Overcast skies, shady places, the golden hours and even nighttime scenes make great matches for long exposure photography. Slower shutter speeds allow more light into your camera, so if the scene is too bright, your camera will not be able to take the shot without overexposing it.

• In cases where the scene is too bright and the camera cannot take the shot without overexposing it, you can attach a neutral density (ND) filter to your lens. Neutral density filters act like sunglasses for your lens; they are a darkened attachable disc or square that reduces the amount of light that hits your image sensor. They come in varying degrees of darkness to suit your slow shutter needs. A polarizing filter will also decrease the amount of light that hits the sensor as well as reduce the glare that reflects off water. It is possible to stack these two types of filters.

• Set your ISO as low as possible when taking slow shutter speed shots in outdoor light. It will make your DSLR less sensitive to the light and yield a slower shutter speed. Also choose a very small aperture like f/22 to let in the smallest amount of light possible.

• Remember that the closer you are to your subject, whether you have zoomed in or are physically close, the blurrier it will be.

• Try taking a slow shutter speed shot of a still object while moving your camera to make it look as if the object is moving. For instance, you can take a handheld shot of a stand of trees, moving the camera up or down as you depress the shutter button. The end result will be an interesting abstract composed of blurred trees.

⌃ Panning - With my camera set to a slow shutter speed, I panned along with my son on his bike, shooting in Continuous Shooting mode (Burst mode). The result is a clear, in-focus subject in motion set against a blurred background, which enhances the feeling of the motion. 15–85mm f/3.5–5.6 lens at 17mm, ISO 100, f/3.5 for 1/64 sec.

Panning

Panning is a slow shutter speed technique where the photographer pans along with her subject, parallel to it, while snapping away in Continuous Shooting mode (Burst mode). The resulting photo yields a clear, crisp subject set against a blurred, whirling smear of a background. Panning shots portray a feeling of forward motion and energy.

Panning Tips

• Subjects that work best for panning move sideways in one continuous direction—not coming towards you or moving away from you—like a person on a bicycle, skateboard, vehicle, etc. Make sure you are parallel to the subject.

• I recommend setting your camera to Continuous Focus mode to avoid the shutter lag that can occur when using One Shot focus mode.

- For the best results, set your DSLR to its center autofocus point, and make sure that center point is lined up with your subject as you follow it.

- Use a shutter speed between 1/60 sec. and 1/10 sec. If you notice there is not enough blur in the photo, slow down your shutter speed, and if your subject and your background are both turning out blurry, you'll need to increase the shutter speed somewhat.

- You can use a tripod for more stability and accuracy. The head of some tripods provides a nice swivel, perfect for panning along with the moving subject.

- Begin shooting right before your subject enters the frame. Pan the camera in sync with your subject, following the path of your subject, while shooting in burst mode. Keep panning and shooting for a moment after your subject has left the frame.

- For a unique nighttime panning effect, use your DSLR's rear curtain flash setting while you pan, where the camera first uses the ambient light to expose the shot and then flashes just before the shutter closes.

- Panning sometimes feels like hit or miss to me. Even with what seems like perfect panning technique, I often fail to get a good shot from the batch. This is actually typical, so don't feel deflated if this happens to you. Try and try again and you will get that perfect shot that takes your breath away.

Gain Further Control With AE Lock

Now that you are exploring the semiauto modes and gaining further creative control of your DSLR, it's time to introduce you to yet another tool that will help you with tricky exposure situations—AE lock. Use the Auto Exposure (AE) lock button if the area you wish to focus on is different than the area you want to meter off of.

Let's say, for example, that my scene has a rocky Maine coastline in the foreground and middle ground, with a gray cottage high on top of a hill in the background, set against a cloudy/overcast, fairly bright morning sky. If I lock focus on the house in Evaluative Metering mode (using One Shot focus mode) and take the photo, the rock outcroppings will turn out underexposed. Why? Because my camera metered (and properly explosed) the brighter part of the scene and not the darker rocks.

Here's where AE lock comes in handy. It allows me to meter off the rocks so they will be correctly exposed, lock that exposure setting, and then focus on the house and take the shot.

I meter off the rocks by locking focus/exposure on them, depressing the shutter button halfway. While the shutter button is depressed halfway, I then press the AE lock button on the back of the camera to lock exposure settings. I can then let go of both the AE lock button and the shutter button, and AE lock will still be activated.

I am now free to take a brand-new shot where I lock focus on the cottage by depressing the shutter button halfway, recompose if necessary with the button still depressed halfway and then take the photo. Note: Your DSLR should be able to use this technique with any AF point.

《 AE Lock Button - In Aperture Priority mode, I used my AE lock button so I could meter off the coastal rocks and then focus on the cottage. I processed this photo in Photoshop afterwards, adding a sepia tint. 15–85mm f/3.5–5.6 lens at 15mm, ISO 200, f/16 for 1/200 sec.

There is a small trade-off in this photo scenario, which you may have already guessed. Because I have metered off the rocks, the cottage and the sky will appear a bit brighter than I wish. There are actually tools for dealing with this kind of exposure problem.

I could use a bracketing technique where I take several different exposures of the same shot and combine them in a software program like Photoshop CS to produce a perfectly exposed shot, known as High Dynamic Range imaging or HDR photography. I could also use what's called a graduated neutral density (ND) filter, which attaches to my camera lens. Half of this type of ND filter is darkened, while the other half is not; just place the darker part of the filter where the sky will be.

Important note: Although I find it fairly easy to use the AE lock button, be aware that some photographers would prefer to meter off the rocks, remember the settings, go into Manual mode and dial in those settings, then take the photograph. Or if a photographer shoots purely in Manual mode, she would meter off the rocks, use those settings for the shot, recompose and then take the shot. It's really a matter of preference. I'm a flutist, so pressing multiple buttons to get the shot is no biggie.

AE Lock and Backlit Portraits

Earlier we talked about using Spot Metering mode when taking portraits with backlighting so that the camera meters off the person, thus properly exposing her despite the backlight. To get the best exposure, I recommend metering off the brightest part of the subject's face. Remember that you want to focus on the eyes.

So, how can one both meter off the brightest part of the face and focus on the eyes? Here's where AE lock comes in handy. You can meter off the brightest part of the face and press the AE lock button to lock exposure settings. Then take the shot as you normally would, aiming the center focus point at the eyes and locking focus by depressing the button halfway again, recomposing slightly if you wish with the shutter button still depressed halfway, then taking the shot. Note: If you have a Nikon or pricey Canon, you should be able to use Spot Metering mode successfully with any AF point. With most Canons, spot metering is fixed to the center of the viewfinder, so it's easiest to spot meter with the center AF point. If you want to use another AF point, it's a little tricky but possible. First select your desired AF point, then place the center of the frame over the spot you want to meter off. Depress the AE lock button to lock exposure. Now you are free to focus using your desired AF point and to take the photo!

New Scenario = New Settings

Be sure to reset your camera settings with each new scenario. You might need to change the white balance setting, choose another AF point, readjust exposure compensation, select another metering mode, etc. Countless times I've accidentally shot with previously used settings that just didn't work with the new scenario.

It's Time!

I hear a drumroll. It's leading us straight to Manual mode, because if you've been working hard on all of the skills in Chapters One and Two thus far, you are now ready to take that step!

The Creative Camera Model for Shooting in Manual

So here you are! You have arrived at a place in your photography development where you, the artist, are taking full creative control of your DSLR. I am proud of you, and I can well imagine that your love of photography and your skills are blossoming and opening into realms that you may not have previously thought possible. At this point, your acquired knowledge should make shooting in Manual mode much less daunting, perhaps even a piece of cake.

You have some choices now as to how you would like to use your camera to capture those scenes that move your spirit. Do you wish to shoot in Manual mode or with the semiautomatic exposure modes? I've heard lots of talk and read countless arguments online about which is better, and personally I don't understand what the big deal is. I don't think one way is supreme, or that a photographer necessarily possesses more skill if she shoots in Manual. It's a matter of preference.

Your DSLR is a tool, plain and simple. It's how you choose to use it, how you take control of it to help you make the best photos you possibly can. Some photographers prefer to shoot in Manual all the time, using their DSLR's internal light meter as a guide to achieving correct exposure. They prefer making exposure choices and corrections by dialing in settings as opposed to using features like exposure compensation or AE lock.

I've noticed that many SLR film photographers who have made the switch to a DSLR often prefer to shoot in Manual. That makes complete sense to me, as it's what they know and have always done. Some professionals prefer to shoot in Aperture Priority mode most of the time, and utilize Manual mode only in special situations when they must have full control of aperture, shutter speed and ISO. I'll give you some examples in a moment.

I shoot in Aperture Priority mode most of the time, because aperture is of utmost importance to me when it comes to making photos. I find it easiest to lock down the aperture I want, and then massage shutter speed and ISO to make it work.

I occasionally use Shutter Priority mode and rarely use Manual mode. If I were to shoot solely in Manual mode, I know that most of the time (except with tricky lighting situations) my process would be very similar to using Aperture Priority mode. I would first consider Metering mode and white balance, pick an ISO speed appropriate for the given light, dial in my aperture choice, and then manipulate shutter speed to bring the digital marker to the center of my light meter to achieve good exposure, which is exactly what the camera does for me in Aperture Priority mode, only faster. Sometimes I need to be fast, or else I miss the shot. If my setting choices are problematic, it's easy enough to massage the ISO/shutter speed combination until it works.

There are those rare special scenarios when Manual mode is always the best choice, when you need full control over all your settings to reach your creative goal and obtain correct exposure. Manual mode is a must when taking photographs of lightning and fireworks, and is very helpful when both aperture and shutter speed are equally important for the creative outcome.

An example of that would be taking a portrait of a wiggly toddler in low light. Aperture is important because I wish to blur the background with a soft bokeh. Shutter speed is important because I have an on-the-go toddler to photograph in low light and need to keep the shutter speed set to at least 1/250 sec. to prevent subject blur.

For bonus goodies and information on this book's e-companion, visit CreateMixedMedia.com/artofeverydayphotography.

63

In situations with plenty of light, obtaining a fast shutter speed is easy. In this case the toddler is moving around outdoors in overcast evening light, so the low light makes it harder to achieve this faster shutter speed. In Manual mode I dial in both my desired aperture and shutter speed settings and am prepared to increase ISO if necessary to maintain 1/250 sec.

Since this book is largely based on choice and inviting *you* to decide how you would like to use your DSLR to create images, I am going to present you with yet another option, a model for shooting in Manual mode that I call my "Creative Camera Model for Shooting in Manual Mode." I am not reinventing the wheel here, but perhaps putting my own spin on similar approaches that are out there in the photography world.

Before exploring this Manual model, I recommend reviewing the Exposure's Magic Three section, found in Chapter One.

The Creative Camera Model for Shooting in Manual Mode—Two Easy Steps

1» Define Your Main Creative Goal

What is most important to you: DOF or movement?

If it's DOF, do you want shallow DOF (a wide aperture like f/4) for a soft, dreamy background that isolates your subject, or do you want greater DOF (a small aperture like f/22) for a landscape shot that's in focus from front to back?

If movement is your main creative goal, do you want to freeze motion with a fast shutter speed (maybe a skateboarder frozen in mid-air at 1/500 sec.), capture motion progression with a slow shutter speed (as in a quintessential waterfall shot with a soft, cotton-candy effect at 2.5 sec.) or pan with a slow shutter speed like 1/60 sec. (resulting in a shot where your subject is frozen in time against a blurred background)? Sometimes thinking about what you don't want, will help you know exactly what you do want.

2» Choose a Primary Camera Setting to Achieve Your Goal, and Support It With Secondary Settings

Your main creative goal determines the primary camera setting, whether it be a wider or smaller aperture or fast or slow shutter speed. Your primary setting is supported by secondary settings (aperture or shutter speed, whichever one you did not select as your primary setting, and ISO) that help to achieve the creative goal and obtain a proper exposure.

Use your DSLR's internal light meter as your guide. Dial in secondary settings that place the marker at dead-center 0 on the light meter, indicating correct exposure. Try to keep ISO as low as possible, as you know. The slightest bit of fluctuation in light will cause the marker to move, so as long as you do not go 2/3 of a stop above or below the center mark, your exposure should be fine.

Keep in mind that your evaluation of "proper" or "correct" exposure involves your personal taste and opinion. Are you looking for more classical shots, or something more creative like high-key photos that are a bit overexposed?

Notes: On occasion, you will have creative goals where two settings are of utmost importance (like the wiggly toddler example). Sometimes you will run into problems with your setting selections. We'll talk about this in The Finer Details section, coming up quickly.

A Shift in Thinking

When making adjustments in Manual mode, you will often need to swap stops, or fractions of stops, because you are the one doing all the work.

For example, if you need an extra stop of shutter speed, you can have it as long as you give up a stop of aperture or a stop of ISO. I think you get the point; it's all about balancing that exposure triangle to achieve correct exposure.

With the semiauto modes, although the swapping of stops occurs when you make adjustments, it feels a little bit different. For instance, when you reduce ISO speed by a stop in Aperture Priority mode, your DSLR swaps it with a stop of shutter speed to maintain standard exposure at 0.

The Finer Details of Carrying out This Model

What exactly do you do once you've determined what your main creative goal is? Start by setting your metering mode (Evaluative/Matrix, Partial, Spot, Center-Weighted), adjust the white balance setting, then carry out step two of your creative camera model as discussed previously.

Try to avoid unwanted aspects like high ISO or a slower shutter speed that could lead to unwanted subject blur. Use your light meter as a guide to arrive at proper exposure. Swap stops to make it work. Perhaps you need a tripod to accommodate a slower shutter speed, or if taking the shot handheld is your only option, you can always bump up the ISO or use a flash.

If you are not able to achieve your creative goal along with a proper exposure, you'll need to go back and adjust your priorities.

Tricky Lighting Situations

Remember all of those tricky lighting scenarios we discussed when special features like exposure compensation and AE lock helped obtain proper exposure in the semiauto modes? In Manual mode you don't have access to those features. Instead you dial in the settings yourself!

Let's say you take a portrait with backlighting and the subject turns out underexposed. All you have to do in Manual mode is increase exposure by one to two stops by manipulating settings yourself. You can widen your aperture, slow your shutter speed or increase ISO.

Remember the rocky Maine coast example where there were dark rocks in the foreground and middle ground and a cottage on a hill in the background set against a bright sky? To achieve proper exposure in Manual mode, you would meter off the rocks in the foreground and use those settings to take the shot.

You've reached a very exciting point in your development as a photographer. You're in the driver's seat now! Congratulations! How will you choose to use your tool to make photographs?

READ ME

In the e-companion to this book, I share a Composition Toolkit of rules, I mean *possibilities*, for creating stellar compositions. I also offer a Bag of Tricks, filled with a list of tools, tips and techniques you can use to ensure your photos come out looking well-focused and well-exposed—even in the trickiest of lighting situations. Visit CreateMixedMedia.com /artofeverydayphotography to learn more.

For bonus goodies and information on this book's e-companion, visit CreateMixedMedia.com/artofeverydayphotography.

65

« Toddler in Low Light - You should go into Manual mode if you need full control over both aperture and shutter speed, as I did here, creating a portrait of this moving toddler in low light by adjusting aperture control for shallow DOF to soften the background and shutter speed control to make sure the speed stayed fast enough to freeze his motion. 50mm f/1.8 lens, ISO 400, f/4 for 1/250 sec.

» Fireworks - My brother-in-law has started a tradition of doing a fireworks display for the family. To capture some of the magic, I placed my camera on a tripod, made sure image stabilization was off, chose Continuous Focus mode, selected an aperture of f/16, set my ISO low to 100, turned the shutter speed to bulb, to allow the shutter to stay open as long as the shutter button is depressed, attached my shutter release cable, relaxed in my lawn chair with a cocktail and pressed the shutter release for a couple of seconds when I saw some pretty ones.

When shooting fireworks, I recommend doing some test shots to see how many seconds work best for you. 15–85mm f/3.5–5.6 lens at 67mm, ISO 100, f/16, bulb.

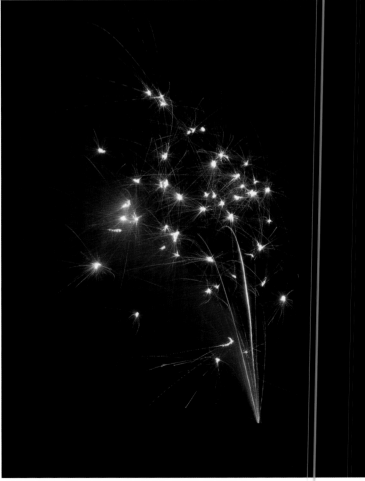

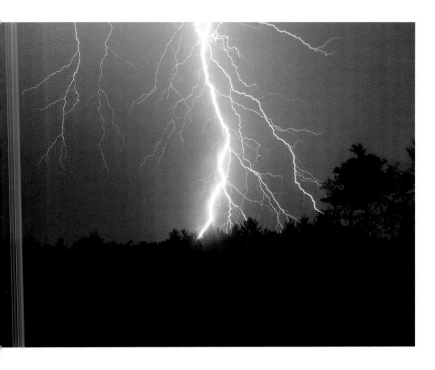

Lightning - Make sure you are in a safe place when photographing lightning. (I was actually looking out a window here.) A camera support is a must and a shutter release cable or wireless remote prevents blur that can result from touching the camera.

It's nearly impossible to anticipate when the lightning will hit, so your best bet is to depress the shutter release for a few seconds using the bulb shutter speed setting in hopes that the lightning will strike during that time. Keep repeating this maneuver and eventually you will record the lightning.

When you do capture those amazing bolts, release the shutter button after the sky goes dark. Be sure to take your setting off of bulb when you are done. If you accidentally take a photo of the sun while in this mode, you can break your DSLR. Be sure to use the lowest ISO possible. 15–85mm f/3.5–5.6 lens at 15mm, ISO 100, f/8, bulb.

Waterfall - I placed my camera on a rock as my tripod wouldn't go that low. Manual mode allowed me to easily manipulate my settings to accommodate the changes in light as I moved about taking waterfall shots. I set the aperture to f/22 and the ISO to 100 to allow for the slower shutter speed. The shade and overcast sky made this daytime long exposure possible without the help of a neutral density filter, which would reduce the amount of light that hits the image sensor.

Using my camera's internal light meter as a guide, I manually set the shutter speed for as long as possible with each different shot, making sure to keep the light meter marker in the center of the continuum, ensuring proper exposure.

I also used the self-timer to avoid camera shake that would result from pressing the shutter button myself. 24–70mm f/2.8 lens at 24mm, ISO 100, f/22 for 2.5 sec. I applied the matte filter from CameraBag software.

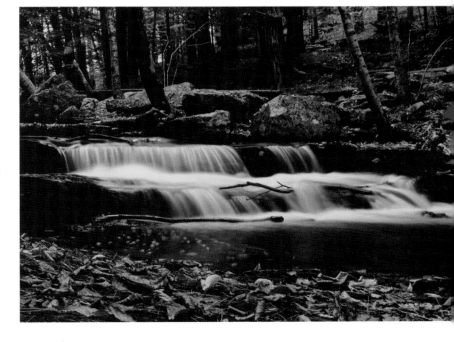

For bonus goodies and information on this book's e-companion, visit CreateMixedMedia.com/artofeverydayphotography.

67

Portraits

> All photographs are
> memento mori. To take
> a photograph is to
> participate in another
> person's (or thing's)
> mortality, vulnerability,
> mutability. Precisely by
> slicing out this moment
> and freezing it, all
> photographs testify to
> time's relentless melt.
>
> » Susan Sontag

Whether portraits are posed and formal or more relaxed and authentic, the photographs we make of family, friends and beloved pets capture and celebrate what we love, what is cherished, what we want to always remember and keep close to our hearts. In this chapter guest contributors and I share tips and techniques that will help you create stunning and artistic individual, group and self-portraits in a variety of settings and lighting situations. We'll share DSLR and mobile phone tips, as well as general artistic tips that you can use, no matter your photographic device.

My Top Portrait Tips for Single Subjects

If the eyes are the window to the soul, then it is the portrait photographer's artistic task to capture the true personalities of her subjects. Doing so will infuse the photographs with life, feeling and meaning, and create keepsakes to be cherished, remembered and passed down. Moments in time captured purely, authentically—that is the art of photography.

Shooting from a place within you and following your artistic instincts as you make photographs is essential, and the only way to create a truly moving photo. To help you realize what your inner creative voice tells you, you must know how best to use your instrument. Here are some technical and practical tips to help you make stunning, authentic portraits.

Setting Is Key
Go for a clean background without extraneous elements.

 Sometimes the unwanted elements can't be helped (like the obtrusive tree stump in the grass), but you can use Photoshop (CS or Elements) to get rid of them. Options include (1) cropping them out with the Crop tool (be sure to keep the same standard printing size ratio if you plan on getting them professionally printed), (2) replacing unwanted pixels with other pixels from your photo using the Clone Stamp tool (like replacing the tree stump with pixels of the grass it stands on), or (3) removing them with the Spot Healing Brush tool (which is also great for eliminating unwanted blemishes and marks).

Adobe offers a free thirty-day trial for Photoshop Elements, Photoshop Creative Suite (CS) and Adobe Creative Cloud (CC), the last of which provides the latest versions/tools for Photoshop, Lightroom and more. If you don't have experience with Photoshop, pixlr.com is a free online photo-editing program that I'm quite impressed with. Its regular editor component operates much like Photoshop Elements. The program has a Crop tool, Clone tool and Healing tool, as well as many other fun tools and features, some of which we explore in the e-companion to this book—available at CreateMixedMedia.com/artofeverydayphotography.

Pixlr has an iPhone app called Pixlr Express+ that contains components of its online version. (It does not contain the regular editor.)

For bonus goodies and information on this book's e-companion, visit CreateMixedMedia.com/artofeverydayphotography.

69

Shallow DOF for Close-Up Portraits

For close-up portraits where your subject is still, I recommend using shallow depth of field. Your subject will be clear and in focus and isolated against a soft, blurred background. Keep in mind that the closer you are to your subject, the blurrier the background will be, whether you're standing close or zooming in close. As you move farther back or zoom out, the background becomes more in focus, even if you have chosen a wide aperture. Don't overdo the shallow DOF, as you'll lose clarity of facial features. I generally don't go below f/2.8 for that reason, unless I want some creative facial blur. Ideal ranges: Use roughly f/4 or wider to create portraits with shallow DOF. Use f/5.6 to f/11 to create portraits with greater DOF.

 For close-up portraits it is important that the camera be aware of your artistic goal to create a soft, blurred background via shallow DOF. The Portrait Scene mode will automatically choose a wider aperture to do just this. If you are working in P mode at this point in your learning, know that you can override your camera's choices at any time using the program shift feature. With a flip of the dial, you can increase or decrease shutter speed and your camera will adjust aperture accordingly. As you increase shutter speed, it makes the aperture wider, and conversely, as you decrease shutter speed, it makes the aperture smaller. Consult your camera's instruction manual for specifics.

 I recommend going into Aperture Priority mode for close-up portraits and locking down a wider aperture setting like f/4, which will yield a shallow DOF. If you are taking a portrait of a wiggly baby or toddler, especially in a low-light situation, you will need to maintain a shutter speed of at least 1/250 sec. to avoid subject blur. In Aperture Priority mode you can indirectly increase shutter speed if need be by choosing a wider aperture or by bumping up ISO. If using Manual mode, dial in your wide aperture, set the ISO according to the available light (stay as low as possible) and dial in a shutter speed, bringing the light meter marker to the center. If shutter speed is too slow, you can gain a stop or two of shutter speed by making a trade-off with a stop or two of ISO, aperture or a combination of the two.

Your smartphone has a fixed aperture—either f/2.4 or f/2.8 depending on the model. The only way to affect DOF is by controlling your distance from the subject. The closer you get to your subject, the more blurry the background will be, and conversely, the farther away you get from your subject, the more clarity you will have throughout. You can apply faux shallow DOF to your mobile photos with apps like LiveDOF, BlurFX, AfterFocus and FocalLab. SynthCam is an app that allows you to simulate shallow DOF while you take your photo.

Lighting Is Very Important

Soft, natural light makes for beautiful portrait photography, whether at the edge of a shady outdoor spot, under the canopy of overcast skies or outdoors during the golden hours with either even front lighting, backlighting (which can give hair that glowing, angelic effect) or side lighting (which gives more dimension). If you are indoors, north-facing windows offer flattering indirect light ideal for portraits. Avoid direct light, as it can cause squinting in your subject and harsh contrasts.

Your DSLR's Portrait Scene mode will work best in soft, diffused natural lighting situations where the subject is evenly lit with either front lighting or overcast light. It can also be used if the subject is at the edge of shade.

Shooting in natural light can come with challenges. What to do with those shadows that darken your subject? You can place a reflector on the opposite side of the light source and bounce the light onto these areas. Or you can place a reflective surface underneath the face to brighten and soften it, especially with top lighting on bright and overcast days.

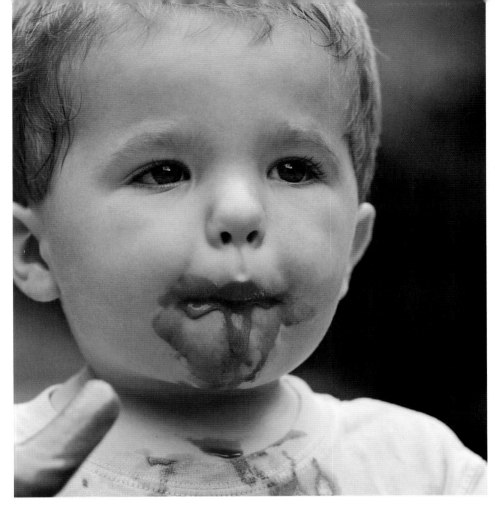

≪ Shallow DOF Portrait- Create a soft background for a close-up portrait by using a wide aperture to yield shallow DOF. This little one was focused on his fudge popsicle, allowing me the fantastic opportunity to photograph him in a natural pose. 100mm f/2.8 macro lens, ISO 200, f/2.8 for 1/250 sec.

If your subject is turning out underexposed due to a bright backlight, you can use your camera's exposure compensation feature to increase exposure by one to two stops, or use Spot Metering mode, which will also brighten the face. Keep in mind that exposure compensation works in P mode, Aperture Priority mode and Shutter Priority mode. In Manual mode, you would increase exposure by dialing in new settings, using the camera's internal light meter as your guide.

Fill flash is a great option for brightening faces outdoors, especially when the sun is behind your subject, not to mention it adds a nice catchlight to the eyes. If you decide to use a flash (indoors or out), I recommend using an external flash unit, powered down for a more natural look. Alternative sources of light to experiment with include candlelight, light from your laptop screen or water (an amazing natural reflector).

You can either bounce the flash off a white ceiling or reflector, or remove it from the camera, attach it to a flash sync cord (or use remote capability if you have it) and direct the flash onto areas cast in shadow. Your flash has the same color temperature as the sun; that's why it looks natural when used outdoors as a subtle fill flash. In some lighting conditions, the flash can appear too cool (when used outdoors in warmer evening light, for example). You can counteract that by choosing a cloudy white balance setting or by attaching a warming flash gel strip to your flash head. Want to know some more photography lingo? Attaching a gel to your flash is often referred to as "gelling your flash."

For bonus goodies and information on this book's e-companion, visit CreateMixedMedia.com/artofeverydayphotography.

71

Focus on the Eyes

Using One Shot focus mode, place the center autofocus point on your subject's eyes. If they are at an angle, focus on the eye nearest you. Depress the shutter release button halfway to lock focus, then recompose your composition if you desire. Recomposing the shot with a very shallow DOF can cause subject blur, so use the AF point that is closest to your subject's eyes instead.

Mind Shutter Speed to Avoid Blur

You can use 1/60 sec. with subjects who are very still. You might need a tripod if this pushes you over your handheld limit. To be on the safer side and for subjects who are relatively still, a range of 1/125 sec. to 1/250 sec. is plenty fast. If you have a wiggly youngster, make sure your shutter speed is set to at least 1/250 sec. to ensure a crisp shot. For faster action shots with people, you shouldn't need any faster than 1/500 sec.

 Use the Portrait Scene mode for portraits where your subject is relatively still. Switch to Sports mode if there is a lot of movement.

 If you are taking the portrait in Aperture Priority mode, keep an eye on the shutter speed if there is movement. If you need to increase shutter speed, bump up the ISO or open up the aperture, or you can always switch to Shutter Priority mode and dial in the faster shutter speed.

Manual mode is another option, especially if managing both aperture and shutter speed is important. Try dialing in your desired aperture, choose an ISO appropriate for the ambient light (trying to keep it low), and then see what shutter speed is needed to bring the marker on the light meter to proper exposure. If the shutter speed is too slow, you can always make a swap, e.g., increase shutter speed by two stops and increase ISO by two stops. Balance that exposure triangle!

Use an Appropriate Lens for Portraiture

A comfortable focal length range for portraits is roughly 85–100mm, although I have used shorter focal lengths for close-up shots and longer focal lengths where I zoom in on my subject from a distance. Wide-angle focal lengths (35mm or shorter) can distort facial features, making them look larger than they are, but if you get in very close to your subject, it's not so much of an issue. Medium telephoto lenses, generally 85–135mm, make great portrait lenses because they compress the background (called lens compression), which makes facial features appear smaller. Another plus is that they allow you to physically step back from your subject and zoom in close, avoiding the awkward and uncomfortable feeling that comes with sticking your camera in their face. Telephoto lenses are also great for photographing toddlers because you can keep your camera at a safe distance from curious wee-one fingers.

There is sometimes a drawback to using a longer focal length, and that is it can make your photos slightly less sharp. There is a fix for this up to a point: Use the Sharpening tool or sharpening function in Photoshop CS or Elements, or in the free Pixlr program (available at Pixlr.com). Tip: You can use a dedicated macro lens as a portrait lens. I sometimes use my 100mm f/2.8 macro lens for taking portraits, as I can achieve a nice blurry, dreamy background with a wide aperture.

Capture the Subject Doing What They Love

I have a special affinity for photographing the subject doing what he loves. This type of authentic portraiture is all about capturing the moment, which holds far more depth and meaning than a posed shot ever could. This style of portraiture will help your subject relax because he is focusing on what he loves as opposed to a poking lens. You will capture personal qualities that infuse the photos with authenticity, passion and life. If your subject is moving around a lot, use Continuous Focus mode.

A Few More Helpful Tips

• For full-length shots, don't crop off limbs. For non-full-length body shots, don't crop at a joint.

• Stand anywhere from 5' to 10' (1.5m–3m) away from subjects. It's best for both subject comfort level and achieving correct proportions.

• Apply the rule of thirds by putting the subject's eyes in the top third of the frame, even if you have to crop off the top of his head. This is a great technique for cropping out baldness. Less space above the head is better than too much.

• Use Continuous Shooting mode (Burst mode) to ensure you get some keeper shots. Burst mode is available with a mobile device.

• Converting photos to black and white adds an elegant, classic feel to your shots, infuses them with a richer sense of feeling, emotion and sentiment, and eliminates distracting mismatched colors. Soft sepia tints nicely complement the tenderness and innocence of childhood photos.

《 Black and White - Converting your photos to black and white gives them a classic, timeless feel and enhances their emotional content. 15–85mm f/3.5–5.6 lens at 85mm, ISO 200, f/7.1 for 1/125 sec.

73

Posing Tips

- Not only do single-subject portraits look more pleasing when the shoulders are at a slight angle, with head facing forward, but this stance can also make large ears appear smaller. Adjust the angle so the ears are not facing straight on.

- To "slim" your subject, try shooting from slightly above them or have them turn their face slightly to one side. Tilting the chin down a bit also creates a slimmer look.

- To avoid looking stiff, have your subject slightly bend a limb or tilt their head.

- Avoid up-the-nose shots for obvious reasons.

- If a subject is wearing glasses, be careful not to capture reflections/glare.

- Profile shots can yield interesting, creative results and look rather dramatic with side lighting, which casts a bright light on the front of the face that recedes into dark shadow. Be aware that this type of lighting accentuates facial features and does not look flattering on everyone.

⌄ Shoulders at a Slight Angle - Straight-on shots with square shoulders can look stiff, even a bit antagonistic. Make sure your subject's shoulders are at a slight angle, with their head turned towards the camera. If your subject wears glasses, be careful to avoid reflections/glare in the glass. 15–85mm f/3.5–5.6 lens at 46mm, ISO 200, f/5.6 for 1/80 sec.

⌄ Profile - Profile shots with side lighting can be tricky, as they accentuate every line, curve, pore and blemish. This subject's strong chin, masculine appearance and the texture of his beard scruff make for a successful profile shot. This photo was taken indoors in low light without flash and with a zoom lens that has a variable maximum aperture. To get the shot I opened the aperture as wide as possible, increased ISO, which in turn increased shutter speed, turned on image stabilization, placed my elbows on the table for camera support and had my subject hold very still to accommodate the slower shutter speed. 15–85mm f/3.5–5.6 lens at 76mm, ISO 800, f/5.6 for 1/25 sec.

> I find everyone beautiful. If I could take a photograph of everyone I meet, just one, I would be a happy person. I hope to show people their inner beauty.
>
> » Erin Little

⌃ Erin and her clients were on the windy coast and she decided to shoot through some tree leaves that were blowing around. She steadied the leaves with her hand in order to frame her subjects.

Capturing Spirit Through the Lens

A Chat With Maine Photographer Erin Little

Professional photographer Erin Little has a gift for capturing the spirits of her subjects through her camera lens. She lets us in on how exactly she goes about doing that. A fascinating process.

Susan » What strikes me most about your portraits is the authentic, natural quality they emanate. Tell us about your artistic process and how you go about getting your subjects to relax and be themselves in front of the camera.

Erin » As a creative photographer, I feel that portraits should reflect the very essence of the subject. I am not looking to capture just their looks, an expression or their style, I am really searching deep within them to have my photographs reflect what makes them tick. I find people absolutely fascinating and there is beauty in everyone. Often people feel so overwhelmed when in front of a camera. Suddenly they seem to have such little faith in themselves and particularly how they appear. I don't connect with people because of the way they are built or whether their hair is straight or curly or frizzy or if they have perfect skin. I connect with their souls.

As a photographer it is my job to get a deep sense of my subjects before photographing them. Sometimes I

For bonus goodies and information on this book's e-companion, visit CreateMixedMedia.com/artofeverydayphotography.

75

"I love contrast with light. I think it creates a terrific mood. This old mill was the perfect place for a shoot and getting creative with the large windows and dark interior," shares Erin.

have only five minutes, sometimes we meet for a drink beforehand and chat to loosen up. But regardless of how much time I have to spend with my subjects before I start photographing them, there is always a feeling I get about someone upon meeting them. So I go with that. People are drawn to my portraits because they reflect the actual people. They appear natural and easygoing. And no matter who I get in front of the camera complaining that they always look awful in photographs, I've never had anyone dissatisfied with their portraits after a shoot. So it's important to get to know your subjects; ask them questions, compliment them, find out what they love and what they do. That connection will really come through in the photos.

Susan » I notice that the subjects in your photos don't look traditionally posed. Tell us more about this.

Erin » As far as directing my subjects, I rarely do it. When people feel comfortable, they tend to position themselves in a way that is natural. And I tell them this upfront before the shoot starts. I will tell them that if they don't hear anything from me, they are doing everything perfectly. I think that helps make my portraits appear very natural.

Susan » Your approach is freeing and clearly works extremely well for you and your clients. As the subjects are positioning themselves, what kinds of things are you doing, technically speaking, to capture the magic?

Erin » My own personal technique as a photographer is to shoot from all different kinds of angles. Shooting through leaves, flowers and other objects to frame my subjects creatively is my favorite. I love shooting through grass. I use a lot of negative space in my photographs to draw the attention directly to my subjects. I avoid busy backgrounds. I often underexpose to create really deep, rich colors and shadows, but just by a little. I love shooting wide open and find that an aperture of f/1.4 if carefully focused can make for an amazing portrait. For professional portraits, I never shoot wider than f/2.8 in order to capture all the important facial features. But creative photography is all about doing things differently, so I typically don't abide by the normal photography rules and do whatever I think would lend itself well to the subject and location.

Susan » Yes, I totally agree. I know many readers would love to know what kind of gear you use to create such artistic portraits.

Erin » I use a Canon 5D Mark III. I had been a Nikon shooter for ten years and just switched to Canon. I really love it, and although I feel good lenses are more important than a fancy camera body, I have to say I am incredibly impressed with what the Mark III can do for me. My favorite lenses are my Canon 50mm f/1.4 and my Sigma 35mm f/1.4. I also have a Canon 100mm lens I use solely for weddings and a 24mm tilt-shift lens, which I have so much fun with! I use only prime lenses and have found that even though I've owned zooms in the past, I never reached for them. I like to move with my subjects. For studio equipment I have some reflectors and Alien Bees lights. I rarely use them though. I prefer naturally lit subjects. For editing I switched from using Photoshop CS5 to Lightroom 4. Lightroom has been great and I love how it has helped me become better organized!

Susan » What's your typical workflow? How many photos do you generally take per session, and what does your post-editing process look like?

Erin » Each job has a slightly different workflow depending on what it is. Weddings are different from commercial work, etc. With portraits I will typically take anywhere from 400 to 800 photos a session. I then pull them into Lightroom and rate them and discard the ones I don't like. From there I adjust things like white balance, exposure, curves, contrast and clarity. I then will add a preset if I choose. Lastly, I export to a folder on my desktop.

For bonus goodies and information on this book's e-companion, visit CreateMixedMedia.com/artofeverydayphotography.

77

⌄ Erin brought the wedding couple out during sunset to play with the amazing golden light. "I wanted to shoot through the field grass to add something creative to the image," she says.

⌃ To really make her subject pop against her surroundings, Erin used a wide aperture to yield a shallow DOF. She underexposed a bit to preserve the lush greens.

Successful Group Portraits

Let's go on a group photoshoot! First and foremost, it's important to establish a good rapport with your subjects and create a relaxed and fun environment. Having that foundation will set you up for success. Below are my top tips for creating group portraits of which you can be proud. You can apply these ideas to taking photos of your own family and friends, as well as sessions with clients.

Your Demeanor Is Important

Your demeanor will help you get the best results, make for happy clients and make for future jobs. When I arrive at a location with a client, especially when it is in her home, I assess her expectations. What are her ideas for locations? Are there any special sentimental places on the property where she would like some shots taken? Does she prefer posed shots, candids or both? Some of these questions can be answered ahead of time on the phone, in person at a consult or via e-mail. At the photo session, I fulfill their wishes while at the same time showing confidence and control of the situation when constructing poses, making determinations based on available light, adjusting my camera, weaving my own ideas in with their expectations, etc. I have a few tricks up my sleeve for making folks feel relaxed and comfortable, and some incentive ideas for kids who are less than enthusiastic.

Harmonious Clothing

It's important that your subjects' clothing not be mismatched or distracting. I suggest to my clients that they wear neutral colors that go together, like gray, burgundy and blue denim. If they prefer more juicy colors, I request that they wear no more than three colors amongst them. The best trick is to pick one or two neutral colors as a base, like white, black, brown or gray. Then add one to two colors in addition to that. Let's say a client chooses white as a base and yellow and blue. The yellows and blues don't have to be exactly the same tones to work together. If you are looking for pleasing color palettes, you can find them online at Design-Seeds.com.

Location, Location, Location

Location will make or break your shots. Make sure that your setting does not have extraneous elements in the way. I've been known to move furniture and clear large fallen branches from the background. Your setting does not necessarily have to be stark, as aspects of the environment can weave very nicely into compositions. For instance, if a family lives on a farm surrounded by a stone wall, take some stone wall shots. Or maybe get creative and pose the family around an antique heirloom tractor. Other possible locations can be gardens, public parks, city streets, the beach, indoors with natural light or an indoor portrait studio if you have the proper equipment.

Hunt for Good Lighting

Look for light that will be evenly exposed on all group members' faces. Stay away from shadows and heavy contrasts. Overcast days and the rich light of late afternoon are ideal and provide even lighting. There is always the shade of a tree on a bright day.

Shooting indoor group portraits is no fun in my opinion, as it is usually a struggle to get even lighting on all of your subjects, unless you're in a studio. Try placing clients near a north-facing window, not in direct light. To brighten shadows indoors use either a reflector, a fill flash or bounce flash. You can bounce the flash off a low white ceiling, white wall or a reflector.

Place Subjects at Different Levels

If you are composing a posed group shot, you'll want to make sure that the subjects' heads are at different levels. In general, stay away from one single row. Visibility of all subjects is key, whether you are taking a posed shot or candid. Make sure you can see everyone's face in the composition. Also make sure there is not too much space in between subjects; think tight but not squished.

For bonus goodies and information on this book's e-companion, visit CreateMixedMedia.com/artofeverydayphotography.

79

 If you're shooting in P mode, you can indirectly manipulate aperture by increasing or decreasing shutter speed with the program shift feature. To obtain a smaller aperture, just decrease the shutter speed by simply turning the dial on the top of your DSLR to the left. For a wider aperture, increase shutter speed by turning it to the right.

 Dial in your aperture setting in Aperture Priority mode or Manual mode and choose an ISO speed appropriate for the ambient light. In Aperture Priority mode, your camera will generate a shutter speed based on your selections. In Manual mode, you dial in a shutter speed that brings the digital marker on the light meter to center. You'll want to keep an eye on shutter speed in either case, especially in low light.

1/60 sec. to 1/250 sec.

This is an acceptable shutter speed range for group portraits. As slow as 1/60 sec. can work for portraits where everyone is still. If you want to be on the safe side and if your subjects are relatively still, 1/125 sec. to 1/250 sec. will ensure sharpness.

If you have wiggly children in the mix, go with 1/250 sec. or a bit faster. If you are in a low-light situation, you can increase ISO or widen the aperture, or do a combination of the two, to obtain the faster shutter speeds, but try not to go any wider than f/8 for group shots, unless you plan on standing farther away or zooming out. Flash is always an option.

 In P mode, you can increase shutter speed by using your camera's program shift feature—just flip the dial to the right. If the aperture gets too wide for a group shot, you can indirectly make it smaller by selecting a higher ISO.

 I personally think it's a lot easier to go into Aperture Priority mode and lock down the aperture you want. If the shutter speed slows too much, increase ISO for a faster speed. Of course shooting in Manual mode is another option. Just enter an ideal aperture for group portraits, anywhere from f/8 to f/11, and dial in an acceptable shutter speed and ISO combination to yield a standard exposure. Swap stops if necessary.

Rather than list a few ideas on poses and perspective, I'd like to share my go-to posing app called Posing App. This app gives tips and tricks and posing ideas for children, women, men, couples, groups, weddings and glamour shots. They make updates that include more posing ideas.

This would be a very handy tool to take with you on your next group photo session. Clients can suggest poses to try from the app, you can suggest them, and you will all have the visual to refer to when setting up the pose. This can also lighten the mood and relax clients, as you can joke about some of the poses that don't quite fit the situation. Check out the app and you'll see what I mean. Tip: For folks with double chins, have them raise their chins a tad to make it less obvious. If they ask why, explain it gives adults a more flattering look.

Use a Reliable F-Number Setting

For a group shot use anywhere between f/8 and f/11. These aperture settings will ensure that all members of the group are clear and in focus. If you decide to use a wider aperture, you'll have to move farther away from your subjects or zoom out to ensure everyone is in focus. Do some test shots to check focus.

<< Creative Posing/Less Formal - This family's home sits on top of a hill with an incredible vista. I did a less formal, more relaxed profile shot of them looking out onto this natural treasure, something which I'm sure they have done many times in their lives. It was a privilege to capture this image, a photograph for remembrance. 15–85mm f/3.5–5.6 lens at 17mm, ISO 200, f/8 for 1/125 sec.

Focus, Focus and More Focus

A general rule of thumb is to focus on the eyes of the person closest to you. I am a huge fan of autofocus, as it tends to produce more reliable results than manual focus.

Continuous Shooting Mode (Burst Mode)

Take at least three shots in a row, instead of one. This way you have choices for each shot and can pick the ones sans blinking, coughing, sneezing, turning away, etc. If you are using a tripod with the camera's internal timer, because you yourself are going to jump into the pose, make sure to set it to Continuous Shooting mode (at least three shots in a row).

Keep Your Camera at Eye Level

Or a bit lower as you compose the shot. This keeps body parts looking well proportioned.

Scan Before You Shoot

Do a quick look-over of the group, making sure folks are looking at the camera, smiling, posed to perfection. Make sure the scene doesn't have any distracting elements and the background is clean. Check to make sure there are no mergers like a big sunflower behind someone's head. You can give a verbal cue if you want to, such as counting to three, so people can scratch their noses before you press the shutter, but whatever you do, don't ask them to say *cheese!* unless you're looking for a bunch of unnatural, forced smiles.

Beware the Eyeglass Glare

Eyeglasses are always a challenge, as you have to carefully compose the shot to avoid glare on the person's lenses. Usually all it takes is a simple slight turn of the person's head, so the light source is no longer reflecting off their glasses. Just be aware of this, as plenty of great shots can be ruined by eyeglass glare.

For bonus goodies and information on this book's e-companion, visit CreateMixedMedia.com/artofeverydayphotography.

81

Silly Shot - This is a rare case where the eyeglass glare adds to the flavor of this silly posed shot. 15–85mm f/3.5–5.6 lens at 38mm, ISO 400, f/8 for 1/160 sec.

Relax Your Subjects for Better Captures

I am a bit of a goof and definitely lighthearted. These personality traits come in handy when helping my subjects to relax and trust in me. Find things to compliment your clients about, show interest in them without prying, even joke around. Of course, everyone has a different comfort zone, so you'll need to adjust accordingly. If they're not the talkative type, you can always tell them about what you are doing, technically speaking, to take their photographs. Stay relaxed and low-key yourself, and enjoy.

Use the prize bag with kids! It contains small rewards like balls, bubbles, trinkets, stickers, puzzles, fun dollar-store stuff. Beware of giving chokeables to babies. To make the babies smile, coo and giggle, or get a little snuggly character to attach to your lens.

Try Less Formal Shots

You might also want to try doing some informal candids of the family engaging in something they love, making for more natural, authentic photographs that are a nice alternative to traditional poses. Continuous Focus mode is preferable. Use a shutter speed of at least 1/250 sec. to freeze motion and 1/500 sec. for faster action.

Creative Posing Ideas

Throw in some fun, creative shots. Have at least one silly posed shot where everyone gets to strike their most ridiculous pose or expression. Kids love to do this, and you can use it as an incentive. Making a silly shot will refresh and energize everyone for the rest of the photoshoot, as well as relax subjects and make the subsequent photos more natural.

《 Focus on the Closest Eyes-
The natural rock outcropping
made it easy for the family
members to position themselves
on different levels. I focused on
the eyes of the boy closest to
me. The dogs were on a hidden
leash, waiting for me to give
them a treat from my pocket.
That trick works with pets every
time. 15–85mm f/3.5–5.6 lens at
26mm, ISO 400, f/8 for 1/160 sec.

《 Group Shot/Selective Focus-
When I'm out with my family on
a day trip, I look for opportuni-
ties to take candids that are a bit
out of the ordinary. In this shot,
selective focus was an option
and I chose the unexpected
by focusing on a portion of the
mums in the foreground, which
served to creatively blur a part
of the foreground as well as my
family in the background. A very
wide aperture played a cru-
cial part in yielding this result.
The overcast sky enabled me
to capture the rich color of the
mums, which adds pizazz to an
otherwise gray autumnal photo.
24–70mm f/2.8 lens at 27mm,
ISO 200, f/2.8 for 1/250 sec.

For bonus goodies and information on this book's e-companion, visit CreateMixedMedia.com/artofeverydayphotography.

83

When using my dedicated flash I choose my aperture and ISO settings in Aperture Priority mode, and let the camera select an appropriate shutter speed. My dedicated flash will sync with the shutter speed that's chosen in an effort to produce a well-exposed shot. Higher-end flashes are capable of syncing with practically any shutter speed, while less expensive ones have limitations. In this example of the couple, I selected f/5.6 to blur the background, but also to retain a little detail in the brick wall. I chose ISO 200 to keep the grain factor low. Because there was low light in this scene, the camera selected a slower shutter speed to properly expose the background, while the flash exposed the subjects in the foreground, an example of slow sync flash photography. This is just like using a technique called "dragging the shutter," where the photographer chooses a slower shutter speed to let in the existing or ambient light of a low-light scene before the flash fires, making for a more natural shot.

I love using this flash method in low-light situations because it yields very natural-looking photographs where both the background and subject are well-exposed, as opposed to having that unappealing, obvious flash look of a ghostly bright subject set against a blacked-out background. The only downside is that you need to hold very still or use a tripod to accommodate the slower shutter speeds that occur in low light; subjects also need to be still; otherwise you get subject blur. If shutter speed gets too slow, you can always increase ISO, which will indirectly increase shutter speed. Raising the ISO, which makes your image sensor more sensitive to the ambient light, will also brighten the background of a low-light scene even more, ensuring depth in your photo. 24–70mm f/2.8 lens at 25mm, ISO 200, f/5.6 for 1/25 sec.

Tip: If you don't have a dedicated flash, you can use your DSLR's built-in flash and rear curtain flash feature, also called second curtain sync, which allows the camera to expose for the ambient lighting in the room just before firing the flash, creating a much more natural look. The downsides of a built-in flash are that you can't reduce its power as much as you can with a dedicated flash unit and you can't remove or angle it, which means you can't bounce it or remove it to create directional lighting. I highly recommend a higher-end dedicated flash unit—worth every penny.

Fill Flash Couple - I placed this couple near a window that allowed indirect, diffused, overcast daylight to hit the left sides of their faces. To brighten the shadows on the other sides of their faces, I used a powered-down Canon Speedlite 580EX II off-camera flash, which I directed at the shadowy areas, creating directional sidelighting that served as a fill. The flash also yielded charming catchlights in their eyes.

Flash Photography Scenario: Use available light in conjunction with flash for more natural shots. For those who know a little bit about using a dedicated flash (or wish to), let me tell you about a simple technique that will make your flash photography look very natural, especially with photos taken in low-light scenes. (I used this technique for this shot of the couple.) The technique is easy, but the reasoning behind it is a little complex.

« Photo by Contributor Vivienne McMaster - "I wanted to capture the magic of gathering with a group of friends for a day of dressing up and having a beautiful picnic and used my camera's self-timer so I could add myself in the photo too!" says Vivienne. Vivienne processed both of her photos in this spread using a Lightroom preset called Summer Wheat B&W. 24–70mm f/2.8 lens at 28mm, ISO 100, f/4 for 1/125 sec.

« Photo by Contributor Vivienne McMaster - Vivienne shares, "There was this most beautiful curve in the rock at this spot, and I wanted to capture this wonderful group of friends in a lovely, unscripted moment of fun and laughter." 24–70mm f/2.8 lens at 68mm, ISO 100, f/2.8 for 1/160 sec.

For bonus goodies and information on this book's e-companion, visit CreateMixedMedia.com/artofeverydayphotography.

85

Self-Portraits

Artists create self-portrait photos for a variety of artistic and personal reasons, perhaps as a form of self-exploration, for a headshot, documentation of an event or a study of human form. I myself explore self-portraiture through my mobile photography and enjoy sharing this particular vein of my work on Instagram and other online mobile photography communities.

Most of my iPhone shots are monochrome, have a time-worn, textured appearance and utilize creative blur. Sometimes I experiment with the form of the human body, while other times you'll find me dressing up in costumes, becoming a character, posing in interesting settings, letting the stories unfold.

I use my own body as the model for my story-telling mobile photos because it's practical, convenient, relaxed and fun. What I find interesting is that I don't tend to think of these particular photos as being self-portraiture; it's more like I am an actress bringing a character in a play to life.

Let go and have fun! Make a date with yourself and try out some of the ideas below.

Necessities
- Tripod
- Use of your camera's or mobile phone's self-timer (set to Continuous Shooting on your DSLR; I recommend three shots) or remote if you have one, so you don't have to run into place and strike a pose before the camera shoots.

Possible Settings
Outdoor environments like gardens, woods and fields make excellent natural settings, indoors by a window, against a white or black backdrop. Make sure the background is fairly simple, without distracting elements that take away from the subject.

Lighting
If outdoors, it is best to shoot during the golden hours, as the light will be soft and diffused. Overcast skies are also ideal. If it's bright and sunny, head for the edge of the shade.

For selfies taken indoors, shoot near a north-facing window that provides soft, indirect light. Stay away from direct light, as it's contrasty. If you have a dedicated flash unit for your DSLR, consider using it as a bounce flash to bounce light onto shadowy areas. Bouncing light onto the subject via a reflector is another possibility. Or try using inexpensive work lights, available at hardware stores.

Technicalities
If you are taking a close-up self-portrait with your DSLR, you already know that shallow DOF will be your best bet (try f/4 or wider). What aperture should you select if you are photographing yourself in a landscape scene?

 If you are taking a photo of yourself in a landscape scene, you will want to choose the Landscape Scene mode on your DSLR. Your camera will automatically choose a smaller aperture to ensure you capture detail in the foreground as well as the background. If a slower shutter speed is generated, I recommend that you hold still if you want to be clear and in focus.

 If you are shooting yourself in a landscape scene using Aperture Priority mode or Manual mode, choose an aperture anywhere between f/16 and f/22 to ensure the most clarity from front to back in the scene. Hold still to ensure good focus with a slower shutter speed. In Aperture Priority mode, lock in an aperture of, say, f/16 and choose an ISO setting appropriate for the light in the scene. The camera will select a shutter speed based on your aperture and ISO selections. In Manual mode, dial in your primary setting, which in this case is aperture. Choose an ISO speed appropriate for the given light, and use the light meter as a guide to dial in a shutter speed that yields a proper exposure.

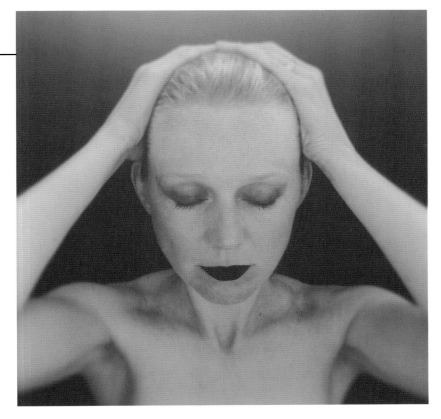

《 I took this iPhone self-portrait, titled *Sweet Gravity,* with the Camera+ app. I manipulated it with a variety of apps to achieve the final result, including Camera+, FocalLab, VSCO Cam and Filterstorm.

 If you wish to sharpen details in your landscape/self-portrait shot, you can do so with sharpening tools in Photoshop CS/Elements or Pixlr.

 Many apps offer sharpening tools, including PhotoWizard, Leonardo, Photogene and Filterstorm.

Creative Self-Portrait Ideas

• Play dress-up. You can create artful shots that tell a story when you don a costume and become a character. This kind of play helps you get out of your own way and enables you to become more fully engaged in the process. Include fun accessories like masks, gloves, hats, fancy shoes and jewelry. Thrift stores are invaluable resources for costumes. I've purchased tutus and fancy dresses for a few dollars each.

• Show some emotion. While you're playing dress-up, it's fun to enact a variety of emotions. Some of the more intense emotions can add powerful drama to your work.

• Pose with a prop. Props can be used to help tell the story or can be objects that have strong personal meaning to you. A few ideas: ornament, vintage telephone, handwritten letter, drinking glass, cup, mug, ribbon or scarf, vintage necklace, gauzy fabric, cape, musical instrument, tiny white lights, book, mirror, flora.

• Engage in an act you are passionate about. Maybe that's painting, dancing, playing a musical instrument or writing—whatever it is that makes you tick.

• Photograph portions of your body. Focusing in on portions of your body can create unique compositions. It is also a very good way to explore form. Consider nontraditional poses—perhaps you will turn your back to the camera and photograph the upper half of your body.

For bonus goodies and information on this book's e-companion, visit CreateMixedMedia.com/artofeverydayphotography.

87

A Tip for Clear Focus

If you are using your camera's built-in timer for self-portraits (DSLR or mobile), I have a trick for ensuring that you, the subject, will be in focus. Take a small slip of colored paper and attach it to the spot (usually a wall) where you will go once you set the timer in motion. If you can, make it level with the location of your eyes, since you will want focus to be there. Lock focus on that paper, so when you stand in front of it, you will be in focus. Make sure the color of the paper is in contrast with the wall. If it is the same or a similar color, your camera will have trouble locking focus.

Mobile Photography Tips

Be aware that your iPhone's front-facing snapshot feature will produce low-resolution photographs. For high-resolution results, you must use the camera on the outside (nonscreen side) of your phone.

This compelling self-portrait was taken by Canadian photographer and dear friend of mine, Susanna Gordon. The viewer makes an immediate connection to the subject through the intense eye contact that she makes with the camera; we see her strength, beauty, passion and kindness. It's all in the eyes. 18–135mm f/3.5–5.6 lens at 80mm, ISO 800, f/5.6 for 1/50 sec.

>> Photographer Erin Little enjoys using her iPhone to make selfies and pictures with her partner, Mark. Her iPhone's portability and ease of use makes it the perfect tool for capturing their love and documenting the everyday moments that make it so special. Erin's favorite go-to app, which is actually the only app she uses on her mobile photos, is VSCO Cam.

⌃ Photo by Contributor Vivienne McMaster - "I actually almost deleted this photo, as I took it as a photo of my whole body and it brought up my inner critic. When I cropped the photo I saw an entirely different story to be told in it, and it ended up being one of my favorites," reveals Vivienne. 24–70mm f/2.8 lens at 34mm, ISO 100, f/2.8 for 1/125 sec.

⌃ Photo by contributor Vivienne McMaster - "To me this image symbolizes a long journey to the feeling of being free and at home in my own skin." 24–70mm f/2.8 lens at 24mm, ISO 100, f/2.8 for 1/80 sec.

For bonus goodies and information on this book's e-companion, visit CreateMixedMedia.com/artofeverydayphotography.

89

Masters of Mobile Portraiture

iPhoneographers David Booker and Edi Caves

The beauty of mobile photography is that it makes photography more available to everyone. David Booker, a masterful portrait iPhoneographer from England, weighs in on this notion. "I think the universal nature of mobile photography is an incredibly exciting development because it allows anyone with a smartphone and an artistic talent to immerse themselves into a creative process that was previously only at the disposal of those who could afford to invest in the equipment. It also takes the emphasis away from producing technically brilliant images with high-end cameras, lenses, etc., to a focus on just capturing and framing a good picture. To then have a wealth of post-processing tools at your disposal anytime and anywhere is nothing short of liberating."

David's emotive portraiture, which is often mysterious in nature, reverently captures the essence of the feminine. I asked him if he had any advice for someone wishing to explore mobile portraiture or photographic portraiture in general. He said, "For me, it's about planning. Think about what it is that you want to capture, what you want the overall look and feel of the finished portrait to portray. Then you can begin to prepare—location, props, lighting, etc. And don't be afraid to experiment and don't be afraid to fail."

》 "This was a shot that I'd been planning for some time. On this particular afternoon the light coming into my studio from an overhead skylight was so strong and direct that I knew I had a limited amount of time to utilize it to my advantage, so it was a race against time to prepare the props and model." —David

David's Artistic Process

"An idea for a theme or finished look or feel is always my starting point, which can often be rattling around in my head for weeks. Once I have the relevant props or costumes, then I'll prepare the studio in my home, an old prison lockup which has incredible light. I usually take a number of images over an hour or so, select half a dozen of those I'm most pleased with, and then spend the next week or two working on them until I have a couple (or more if I'm lucky) that I'm satisfied enough to show.

"I currently use an iPhone 5 for taking photographs (no lenses or attachments) and an iPad for post-processing. For taking images I use various lens and film combinations within Hipstamatic, an incredibly powerful and versatile app. When it comes to post-production, my starting point for reframing and adjusting levels is almost always Snapseed. I then take my images through a number of other apps, including Cameramatic, Photogene 2, ScratchCam, BlurFX, Decim8 and Slow Shutter Cam and many others."

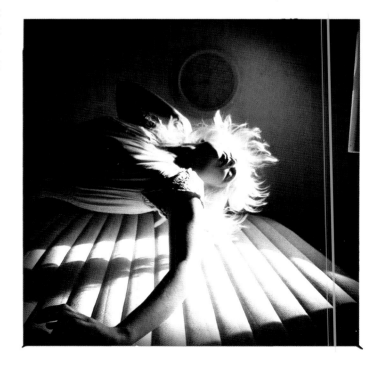

 I Want to Find Myself by the Sea, in Another's Company.
"Anywhere but here is where she would rather be." —Edi

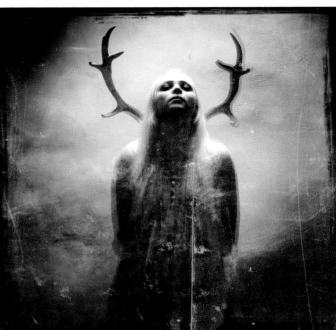

"These antlers hang in a local cafe and I'd been determined to borrow them for a shoot since the moment I saw them. I love the majesty created by the combination of the model's striking pose and these magnificent antlers." —David

Edi's Advice for Candid Portraits

Edi Caves, founder of the popular mobile photography site called iPhoneOgenic, not only provides the mobile photography community with a wonderful resource but is also a talented mobile photographer in his own right. His candid portraits are just that—candid. The feeling and emotion, so apparent in subject body language, draw the viewer in. I asked Edi to share his most essential mobile portraiture tips with us, and here they are.

- "Although shooting in portrait mode (vertical orientation) may feel like the most natural and comfortable position while shooting, I've found that landscape mode (horizontal orientation) is less threatening to the subject and will allow you to balance your composition.

- "Yes, there are lens attachments for your mobile device, but they have their limitations. The best practice is to use your feet—get closer to your subject; the rule of thumb for mobile photographers is to be 4' to 6' (1.2 to 1.8m) from your subject. Never use the digital zoom on your mobile device; you will sacrifice image clarity and quality."

Edi's Artistic Process

"I browse my camera roll, looking to get inspired. Sometimes my mood helps determine the route an image will take, or at times it's spontaneous; the image just speaks to me. I try not to force creativity by allowing the apps to overpower the image and become the image. The best results for me are when prior techniques I've used blend well with new experiences. Currently my most favorite photo app is VSCO Cam. The filters are well-crafted and the UI (user interface) is flawless and intuitive. Other apps I use include Repix, ProCamera, BlurFX, Popsicolor, Superimpose and Blender."

For bonus goodies and information on this book's e-companion, visit CreateMixedMedia.com/artofeverydayphotography.

91

Still Life & FOOD Photography

What's really important is
to simplify. The work of
most photographers would be
improved immensely if they
could do one thing: get rid
of the extraneous. If you
strive for simplicity, you
are more likely to reach
the viewer.

» William Albert Allard

When you photograph still-life and food photography scenes, you truly make photos, as opposed to taking them. The scenes you construct involve elements like form, color, texture and often creative use of light, artfully combined into a cohesive presentation that delights the senses of all viewers and invites them to appreciate everyday objects and the preparation and ingesting of food on a whole new level.

This type of photography elevates these aspects of daily living to that of art and invites viewers to live more mindfully, more creatively and with gratitude. I am inspired daily by the work of stylists and photographers whom I see in lifestyle publications and venues like Pinterest. Often the simple, minimalistic compositions make the strongest visual impact.

This chapter is filled with lots of tips and tricks for creating gorgeous still-life and food photography scenes. There's even a professional food stylist/photographer/cookbook author in the house, who is sure to inspire. And what if I told you it is possible to create amazing still-life photography using a mobile phone? One of my guest contributors lets you in on her secrets for doing so. But the best part about photography involving food is that you get to fully enjoy your art on a visceral level once you put the camera away.

Infuse the Everyday With Life

There's something special about a simple everyday object that is or was valued by a person in some way, whether it be a bread bowl that was passed down from a great-grandmother, a baby rattle, one's favorite flower or an antique car on the side of a country road. Whether you are setting up a still-life photo shoot or taking a photograph of an existing or naturally occurring one, you can capture the personal stories and energies behind these treasures and infuse them with a life all their own.

Considerations for Still-Life Photos

Subject

Take a photowalk around your home, a shop or even a city block. What objects are you drawn to and why? If they are your personal items, what value do they have to you? What stories do they hold? You can photograph an object exactly as it appears in its environment, or if it is an object in your home, use it to create your own still-life scene. It is fun to play two or more objects off each other or use secondary objects to support a primary object (e.g., sliced apple on a board with beautiful scratches and patina, with an antique paring knife artfully placed next to it.) Collections of objects are also a lot of fun to arrange and photograph. Keep in mind that the eye prefers to see odd-numbered groupings over even ones.

Setting and Backdrop

When I take still-life photos I often move the objects to a clean, simple setting near a natural light source. I love taking photographs of objects near windows and am captivated by the way light plays upon them, shaping them, emphasizing their contours. Indirect, diffused window light is usually preferable to harsh, direct light; however, direct light can be used for dramatic effect. If you are setting up your own still-life scene, try using a piece of fabric for the backdrop. Burlap is simple, clean and adds a rustic flare. Make sure it is free of wrinkles and use it to create a smooth sweep to put your objects on. You might also want to try placing your objects on a reflective surface, so you get some interesting reflections in the shot. Shooting outdoors is another option. Take a little road trip in your town and photograph objects that speak to you.

Lighting

Play with natural light sources during different times of the day to create a variety of moods and effects for your still-life photography. The light's quality will change throughout the day, depending on where the sun is in the sky. Think about the direction of light and how you want it to hit your objects. For instance, light in the late afternoon hitting your object from the side will emphasize the shape of your object, create depth and long shadows and give a dramatic effect. An object on a windowsill lit from behind takes on a glowing, ethereal quality. Look for interesting contrasts, patterns and shadows and think about how you could set up a still-life scene to incorporate these elements of interest. If you want to brighten the scene and even out the tones, you can play with reflectors to bounce light onto the shadowy areas or use an external flash unit either as a fill flash or bounce flash.

Composition and Perspective

Think about how you want to capture your subject. What elements do you want in your composition? How do you

For bonus goodies and information on this book's e-companion, visit CreateMixedMedia.com/artofeverydayphotography.

93

want to frame the scene? Where do you want the objects to appear in your composition—dead center, off to the side, in the lower region of your photo? You can try experimenting with the rule of thirds by placing your significant object in the center of one of the vertical lines, or try more unconventional and unusual compositions. Perhaps you will photograph a taxidermy moose head—sorry, I'm a Mainah—in the upper-right portion of your photo. Consider leading lines and where you want the viewer's eye to travel. Do you want to shoot from above, close-up at eye level, from an angle, straight on?

DOF

I particularly enjoy taking close-up, intimate photos of objects with shallow DOF, so I get a clear subject set against a soft, blurred background.

 Use the Portrait Scene mode or the Close-Up/ Macro Scene mode to achieve shallow DOF.

Use a wide aperture in Aperture Priority mode or Manual mode to achieve shallow DOF. I often shoot still-life scenes with my 50mm lens wide open (f/1.8) or close to it, because I enjoy the intense amount of blur. When using very shallow DOF, be careful to keep the significant portions of the object within the small slice of DOF. If wide open is too intense for you and you wish to have your object more in focus, try stopping the aperture down a bit. If you want to capture some detail in the background, stop down even more (try f/5.6).

Do some test shots to see which aperture you prefer. Use f/4 or wider to create still-life shots with shallow DOF. Use f/5.6 to f/11 to create greater DOF.

In Aperture Priority mode, lock in your aperture choice, choose an ISO appropriate for the lighting, and observe the shutter speed your DSLR selects for proper exposure. If it's too slow for a handheld shot, mount your camera on a tripod, set the ISO as low as it will go to achieve the best photo quality, and take that long exposure shot. Use

a remote shutter release or the camera's built-in self-timer so you don't have to touch the camera, causing blur.

In Manual mode, dial in your aperture setting and an ISO that's a good match for the light in the scene. Select a shutter speed that brings you to a correct exposure. Use a tripod if the shutter speed is too slow for a handheld shot. Use the lowest ISO possible with a tripod and still-life scene, to ensure the best image quality. The still-life won't be walking off, so your DSLR can take its sweet time with a long exposure.

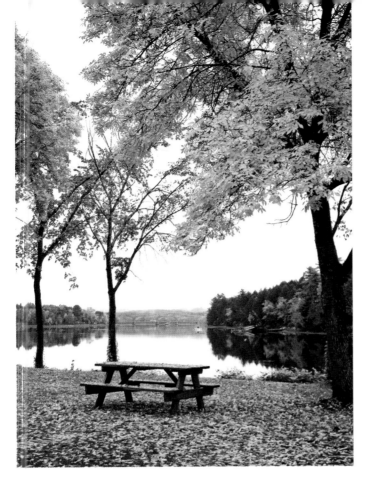

《 It was late winter in Maine and I was feeling color-thirsty. To liven up my blog, which was filled with the neutral, muted tones of winter, I took shots of juicy-colored everyday objects around my home and made them into this collage using Photoshop.

Subject Matter Ideas

household items • art supplies • collections • vase of flowers • bowl of fruit • stone construction • natural objects (stones, feathers, bark, mushrooms) • food • picnic spreads • vintage books with interesting spines and covers • shop window displays • debris on the street • outdoor flower boxes and arrangements • colorful parked bicycles • fountains • twinkling lights • clothes drying on a line • old tractor in a field • candles • antiques/retro items • baked goods • musical instruments • jewelry • candy • party favors • gifts • mortar and pestle • hanging herbs

《 Some of the most beautiful still-life scenes are those that echo the stories of those who have lived in them. 24–70mm f/2.8 lens at 27mm, ISO 200, f/7.1 for 1/80 sec.

DSLR Camera Tips in a Nutshell

Spot Metering mode or Partial Metering mode can come in handy for indoor still-life photo shoots where there are heavy contrasts between light and shadow, especially if there is backlighting. In this mode your camera calculates for the proper exposure of the object, despite the background lighting. Then again, you might like to embrace the interesting contrasts and the silhouette effect you can achieve by shooting in Evaluative Metering mode.

If you are dealing with overall low light, you can either place your camera on a tripod to accommodate the slow shutter speed, bump up the ISO for a handheld shot, or use an external flash, bouncing it off a white ceiling or reflector or removing it from the camera and using it as a fill flash.

When using a tripod, use your camera's built-in timer to avoid jostling the camera as you press the release (or use a wireless remote or a shutter release cable.)

Your DSLR's Live View feature is helpful when taking still-life photos. It displays the scene you are about to photograph on your DSLR's LCD screen and is a great way to check for correct exposure and clear focus before you take the actual shot. When using this feature to check focus, it works best if the camera is on a tripod. I recommend zooming in to check for clarity, as it's hard to tell otherwise. If checking exposure, it works effectively only with Evaluative Metering mode.

Is it possible to take stellar still-life shots with a mobile device? You betcha. Mobile photographer Cindy Patrick is here to show us just how.

For bonus goodies and information on this book's e-companion, visit CreateMixedMedia.com/artofeverydayphotography.

95

⌃ This still-life photo marks an important day, the day my family and I went to the violin shop to purchase the violins we had been renting. In Photoshop, I converted the tones to sepia and subtly applied a texture by Nicole Van. 50mm f/1.8 lens, ISO 1600, f/1.8 for 1/20 sec.

⌃ I collect antique silverware because I enjoy serving and eating with utensils that have a history and because they make such beautiful time-worn props for both still-life and food photography. 50mm f/1.8 lens, ISO 400, f/2.2 for 1/125 sec.

≫ This example of still-life night photography, shot in Aperture Priority mode, calls for the use of a tripod and the camera's built-in self-timer to avoid blur that results from manually pressing the shutter release. Because the subjects were inanimate, I could set my ISO to 100 to avoid grain and wait as long as was needed for the camera to correctly expose the shot. Because the camera initially over-exposed the shot, I used exposure compensation to reduce exposure by two full stops. 24–70mm f/2.8 lens at 24mm, ISO 100, f/8 for 10 sec.

≫ I happened upon this window display of used ballet slippers and found myself studying each one—observing the wear and tear, imagining the ballerinas giving their all to the dance and also cringing at the thought of the pain their feet must have felt. I altered the tones of this photograph with software called CameraBag, applying its matte filter. 24–70mm f/2.8 lens at 24mm, ISO 1600, f/2.8 for 1/80 sec.

Still-Life Mobile Photographer

Cindy Patrick's Go-To Apps and Unique Editing Process

Shoot subjects that interest you and those you feel a natural affinity for. Your passion will shine through in your work.
» Cindy Patrick

iPhoneographer Cindy Patrick currently uses the iPhone 5 and the newest generation iPad to create her painterly style mobile photo masterpieces.

In Cindy's own words, "I shoot the photos with my iPhone and edit primarily on the iPad simply because of the size of the screen. I find it to be much easier on my eyes for some of the fine detail work I do. I have a Wacom Bamboo Stylus that I use with my iPad for editing. I own over two hundred apps but tend to use only a handful at any given time. My work is very painterly. The apps I now use to get that look include Slow Shutter, BlurFX, Repix, Glaze, ShockMyPic, TangledFX, DistressedFX and Laminar Pro.

"The first thing I usually do with an image is enhance or change the color in some way by applying a filter. CrossProcess is a favorite filter of mine. I then make several copies of the image, each one put through a different app. I layer these different versions together in Superimpose, using blending modes to enhance tones and masks to erase parts of layers."

Elemental No. 1 - "This work is the first in an ongoing series of underwater still-life photos. I took a wilted flower and held it underwater in a swimming pool, shaking it around with one hand to create the bubbles as I pressed the shutter of my iPhone with my other hand. I blurred the background and enhanced the color to give it a painterly look." —Cindy Patrick

Dear Diary - "This image is from a larger series of still-life pieces depicting simple objects. It is a tiny, very old diary belonging to a friend's grandmother. The grunge adds to the sense of age, and the handwriting in the background lends a sense of mystery about what is written inside." —Cindy Patrick

Food Photography

Attention all foodies! The next best thing to tasting delicious food is the joy of photographing it. In this article I'll give you some practical information for food photography, as well as inspirational ideas for capturing these delectables through your lens. When it comes to food photography, my favorite go-to lens is my 50mm f/1.8 prime lens, as it allows me to take close-up shots with shallow or very shallow DOF. If I want to capture a broader perspective, I switch to my 15–85mm f/3.5–5.6 lens and use a wide-angle focal length.

DSLR Tips

If you are shooting food in a restaurant under tungsten light (incandescent light), set your white balance to Tungsten. This will help to cool the photo and counteract the yellow tones that result from the temperature of this light.

In low-light situations you have some choices. You can increase ISO to make your DSLR more sensitive to the available light, use a reflector to bounce natural light into the shadowy areas of the scene, use an external flash unit and bounce it off a white ceiling or reflector, or power it down and use it as a fill flash. A diffuser dome placed over your flash will help to soften the bounced light. Or place your camera on a tripod to accommodate a slower shutter speed; you can use your lowest ISO setting on the tripod. If you are in a restaurant setting, I don't recommend using flash, as it's intrusive to diners. And, um, keep the tripod and reflectors at home, too.

As with still-life shots, using a shallow DOF is preferable. Use your camera's Portrait Scene mode or Close-Up/Macro Scene mode to achieve this. If using P mode, keep an eye on the aperture to make sure it's wide enough for you, and it should be, especially if you are taking the photo in lower light. If you need to adjust aperture size in P mode, you can indirectly do so with the program shift feature. Turning the dial to the right will increase shutter speed and indirectly give you a wider aperture. Turning the dial to the left will decrease shutter speed and indirectly give you a smaller aperture. Always keep an eye on shutter speed—in lower light situations it will always be on the slower side. If it slows too much for a handheld shot, take out the trusty tripod. If you want to take the shot handheld, bump up the ISO. Flash is always a possibility.

Try stacking macarons or cookies for a pleasing shot. They don't have to be perfectly stacked; in fact the off-kilter look of this pile of macarons adds visual interest to the shot. I used a white wooden stool seat for the table top and white posterboard for the backdrop, which actually took on a pleasing creamy-peach cast in the given ambient light. 50mm f/1.8 lens, ISO 400, f/5.6 for 1/60 sec.

For bonus goodies and information on this book's e-companion, visit CreateMixedMedia.com/artofeverydayphotography.

99

I used my zoom lens with wide-angle capability to get this shot of ingredients I used to make a hearty fall soup. Most of the vegetables came from our garden, infusing the photo with personal meaning. 15–85mm f/3.5–5.6 lens at 22mm, ISO 400, f/4 for 1/25 sec. with image stabilization.

In Aperture Priority mode or Manual mode, select a wide aperture (lower f-number) to achieve shallow DOF. If you want to capture some detail in the background, use a smaller aperture (greater f-number) like f/5.6 and see if it appeals to you. Smaller apertures will slow the shutter speed too much in low-light situations, so you'll have to accommodate with one of the techniques aforementioned. Ranges: Roughly f/4 or wider to create foodie shots with shallow DOF. Use f/5.6 to f/11 to create greater DOF. Specifics: In Aperture Priority mode, select your ideal aperture, choose an ISO that's a good match for the light, and the camera will select a shutter speed that balances out settings for a proper exposure. If the shutter speed is too slow, you know what to do at this point in your learning. In Manual mode, dial in that aperture you love, choose an appropriate ISO (the lower the better), and bring the light meter marker to center with your shutter speed setting. Mind the shutter speed and have the tripod or flash on hand.

The lovely thing about a mobile phone is that you can carry it with ease on your person. You can pull it from your pocket and take a quick snapshot of your food at a cafe or coffeehouse. It's also nice to have when you don't feel like lugging your DSLR and lenses around. My kiddos and I went strawberry picking, and the last thing I needed was to have a bulky DSLR to carry around in the dusty dirt while trying to pick and carry all the quarts of fruit.

High-key or slightly over-exposed food shots are trendy these days (as are slightly underexposed, darker, richer shots of food set against slate gray and black). I like both equally but have experimented more with the former. To achieve a high-key look I use exposure compensation to increase exposure by a stop or two, and for a slightly underexposed look I use exposure compensation to decrease exposure by a stop or two. If you are shooting in Manual mode, you do not have access to exposure compensation, so you must slightly over- or underexpose when dialing in the settings manually.

You can increase the brightness of your photo in the post-editing stage to achieve that high-key effect. In Photoshop CS/Elements you can increase brightness or manipulate levels or curves to achieve that slightly overexposed look.

With mobile phones, you can manipulate brightness/exposure with apps like PhotoWizard, Leonardo, Filterstorm, Photoshop Touch, Photoshop Express or Photogene. Camera+ offers filters to alter the tonal values.

Get Inspired!

Flip through your favorite food magazine or cookbook and notice what types of shots you are attracted to. Do you like backgrounds that are blurred or ones that show more detail? Do you like when portions of the food are blurred, or would you prefer the food to be more in focus?

Inspirational food photography Web sites »
Tastespotting.com, Foodgawker.com, Pinterest.com, Kinfolk.com.

Foodie photographers I enjoy »
AliceGao.com, WhatKatieAte.com, RoostBlog.com, PiaJaneBijkerk.com.

For bonus goodies and information on this book's e-companion, visit CreateMixedMedia.com/artofeverydayphotography.

101

Tops Tips From a Food Stylist

Food Photographer Celine Steen

I love to shoot peaceful slices of everyday life, like a breakfast table loaded with baked goods and a steaming cup of coffee or a pretty slice of cake. I find that such scenes are soothing and beautiful in their simplicity, and nothing makes me happier than getting to translate that sense of calm and peacefulness into actual pictures.

» Celine Steen

Food photographer, food stylist and cookbook author Celine Steen gives us some more great tips for taking stunning foodie photos.

Celine's Gear

"I use a Nikon D700 almost always fitted with a 60mm f/2.8G macro lens, occasionally with a 50mm f/1.4D lens. My absolute favorite lens is the 60mm macro. It has wonderful bokeh capacities, is sharp, light, fast, rather affordable, and perfect for food photography in low-light conditions when combined with a tripod.

"I don't use any studio equipment other than a light reflector. As far as software programs go, I use Photoshop CS and on occasion, Lightroom. Both programs are used in order to adjust exposure, color balance and contrast."

Celine's Food Photography Tips

- "Morning light or early evening light is amazing to create slightly moodier, dreamy shots."
- "The food is your focus. It can be fun using a bunch of props to tell a story, but remember the food is supposed to be the star of the show."
- "Shoot from various angles to find the one where your food looks best."
- "Prepare ahead of time. I often set up the styling and props in my head before the shoot, cataloging all the dishes, fabric and other props I could work with. That allows me to figure out what will work best ahead of time, instead of just throwing things together at the last minute. Most of the time it works well, but on occasion it just doesn't flow perfectly on a visual level, so I have

to switch to different items in the middle of the shoot. It can be a problem when shooting food items that can wilt or melt quickly; that's why it's best to try and figure it out ahead of time."

- "Spraying fruits and veggies with a little spray bottle of water is a great way to keep things looking fresh and appealing. Another useful trick is to slightly undercook the food so it doesn't look overdone and mushy in pictures."

« "It seems impossible for raspberries and other fresh berries to ever look nonphotogenic! I'm fond of the detailed appearance of the berries obtained by using a macro lens here."
—Celine Steen. 60mm f/2.8 lens, ISO 640, f/7.1 for 1/20 sec.

≪ "I find this image to be a good reminder that you don't always need to perfectly center the main subject of the shot for it to work well."
—Celine Steen. 60mm f/2.8 lens, ISO 400, f/5 for 1/60 sec.

For bonus goodies and information on this book's e-companion, visit CreateMixedMedia.com/artofeverydayphotography.

103

Landscape & Nature Photography

A picture is the expression of an impression. If the beautiful were not in us, how would we ever recognize it?
» Ernst Haas

Everyone can find a sense of place in the outdoors. Think of the soothing, calming feeling that comes from a walk in the woods. The routines, obligations and stresses of daily life fall away quickly as we surround ourselves with flora, fauna, the sounds of leaves underfoot and the breeze through the trees. We become aware of the heartbeat in our chest.

When we bring a camera along on an outdoor adventure, we naturally become more of an observer, looking to photograph something in the scene that moves us. Maybe it is the tangle of branches above or the patches of cornflower-blue sky peaking through. Or perhaps we are down on the ground, intrigued by colorful fungi or the monotony and muted tones of a carpet of dead leaves.

You don't necessarily have to travel outside a city to find this type of beauty—parks, community gardens, even flower boxes can hold natural treasures. In this section of the book, we explore how to make a variety of landscape and nature images, both with a DSLR and a mobile device. We'll discuss how to shoot broad landscapes, close-up and macro scenes, flora and fauna, sunsets, water, urban landscapes and more.

Landscape Subject Ideas

Landscape shots often look best when taken during the golden hours. So get up early and grab your camera bag, a tripod and a fresh hot coffee and head out to photograph beautiful farmlands, rolling hills and valleys, the coastline or even cityscapes. Or postpone your supper and embrace the hours just before sunset. Sometimes we have no other choice but to photograph landscapes in the bright light of day, like when we're on vacation or taking a day trip. In these cases, I often look for water shots and interesting dappled sunlight playing upon surfaces.

Ideas for Your Photo Adventures

Water

Capture running water, waves, rocky seacoasts and coves, waterfalls, and lakes and ponds. Some off-the-beaten-path ideas include photographing reflections that you see in water, getting into the ocean and turning your body 90 degrees to photograph the ocean from the side, or sinking into the water to capture the crest of it, which is best done in a lake or calm cove where there is movement but not a chance of a crashing wave taking your DSLR out. Decide if you want to freeze the motion of the water with a fast shutter speed, or capture motion blur with a slower one.

If you want to freeze the motion of the water, choose the Sports Scene mode. If you want a very slow shutter speed to capture motion blur, shoot in P mode where you have more control. In P mode you can override the camera's shutter speed selection and choose a slower shutter speed; just flip the dial to the left and try 1/2 sec. or slower and make sure your ISO is set as low as possible. And yes, a tripod is a must.

Keep in mind that a slower shutter speed shot may not be possible in bright light.

Stopping the motion of the water: Choose a fast shutter speed in Shutter Priority mode, or Manual mode if that's your preference, to freeze the motion of the water. How fast of a speed you choose depends on how fast the water is moving—the faster the water, the faster the shutter speed needs to be to freeze it. I recommend 1/500 sec. or faster.

Aim to set ISO low and see what kind of aperture is required to make the correct exposure. If shooting in the bright light of day, getting a correct exposure will be easy. If the light is a lower light, just before sunset, it will be more of a challenge to keep shutter speed fast. If light is low, try going into Manual mode. Enter your desired fast shutter speed. Massage aperture and ISO settings to maintain the fast shutter speed and achieve a correct exposure.

Blurring the water, as in the classic long-exposure waterfall shot, is easier to shoot in Manual mode. Choose the lowest ISO possible to make your image sensor less sensitive to the ambient light and a very small aperture like f/22. Dial in the slowest shutter speed possible given the ambient light, keeping an eye on the light meter as you do. Half a second or slower is ideal.

For bonus goodies and information on this book's e-companion, visit CreateMixedMedia.com/artofeverydayphotography.

105

Keep in mind that bright light situations may not allow for the slow shutter speed you desire. In this case you can attach a neutral density (ND) filter or a polarizing filter to decrease the amount of light that hits the image sensor, or you can change your creative goal and choose to freeze the motion.

Fields and Plains

Cloud formations and colorful sunrise or sunset skies look stunning set against simple settings, but sometimes these scenes are barren and lack a focal point. In these cases you can add a person to the composition or capture an object like a farm tractor—something that the eye is drawn to and something that gives perspective to the landscape. You can use the rule of thirds in this instance, and place your subject on one of the vertical lines of the imaginary grid or real grid if your DSLR or iPhone camera app has that feature.

Mountains and Valleys

Look for scenes where you can capture clearly defined foregrounds, middle grounds and backgrounds. Having all three gives depth and dimension to your landscape shots. It's fun to play with the rule of thirds with these types of landscape scenes. Try framing the valley in the lower third of the grid, mountains in the middle third and the sweeping sky in the upper third. Or place the valley in the lower and middle parts of the grid and the mountains and sky in the upper third.

Forests

A photo of a forest taken from afar is gorgeous, but also consider taking a walk in the woods. What are you drawn to? Notice plant life and textures, shoot from different vantage points (it's amazing to get down on the ground and look at all the different varieties of moss) and photograph

⌃ When it comes to landscape and nature shots, feel free to embrace dappled sunlight. The dappled light filtering through the trees onto this duck pond mixes with and highlights the shapes of algae, making for an interesting composition. The very wide angle I achieved with a short focal length makes for a shot that's borderline fish-eye-lens style. 15–85mm f/3.5–5.6 lens at 15mm, ISO 400, f/5 for 1/100 sec.

« I took this sunset shot from a park in Portland, Maine. The fabulous view of cloud formations, rolling hills and signs of human urbanization were lit from behind and above, creating both an ethereal, glowing effect and a stunning silhouette. The sun rays that stretch across the width of the scene really make the shot. 15–85mm f/3.5–5.6 lens at 40mm, ISO 100, f/14 for 1/160 sec.

interesting shapes and shadows created by light filtering through the trees. Forests often have floors strewn with branches, fallen trees, etc. These things can be distracting in a photo. An easy remedy is to shoot up and avoid shooting the messy floor.

Weather

Some of your most exciting photo ops occur when the weather is bad or as a result of bad weather. Capture lightning, storm clouds, fog, rainbows and reflective rain puddles—they make for dramatic, moving shots.

Lines, Shapes & Textures, Rich Color, Shadows & Light

Look for elements like leading and meandering lines, natural formations with eye-catching shapes and textures, colorful flora and skies, interesting shadows cast by clouds and trees, sun rays bathing a landscape and dappled light playing upon surfaces. When you see something that sparks that gut feeling, don't over-think; just shoot!

For bonus goodies and information on this book's e-companion, visit CreateMixedMedia.com/artofeverydayphotography.

107

⌃ Barren landscapes like fields and plains and even bodies of water sometimes need a focal point to add interest to the scene. My son in the water playing make-believe with his towering branch created beautiful ripples on the glassy surface and added a point of interest to an otherwise mediocre shot. 15–85mm f/3.5–5.6 lens at 32mm, ISO 100, f/8 for 1/200 sec.

⌃ Summer storms immediately followed by the sun are a trigger for me to grab my camera and run outside in search of a rainbow. I found this one directly over my favorite apple tree. 75–300mm f/4–5.6 lens at 75mm, ISO 200, f/4.5 for 1/100 sec.

❯❯ I stood in the waves and turned my body 90 degrees to the right, squatted down a bit and pressed the shutter release. Shooting the waves from this angle gives more depth and dimension to the shot. The bright light in conjunction with a wide aperture yielded a very fast shutter speed, which froze the fine details of the waves. 50mm f/1.8 lens, ISO 100, f/4 for 1/3200 sec.

« Avoid capturing a messy forest floor with distracting elements. A simple solution is to shoot up. 100mm f/2.8 macro lens, ISO 100, f/6.3 for 1/200 sec.

« Look for interesting textures in nature, like the surface of a body of water on a breezy day. I took this shot of a lake from the vantage point of a mountain hundreds of feet above the ground, looking out. The boats and the lines/shapes made by their wakes added even more interest to the textured water. 15–85mm f/3.5–5.6 lens at 50mm, ISO 400, f/16 for 1/200 sec.

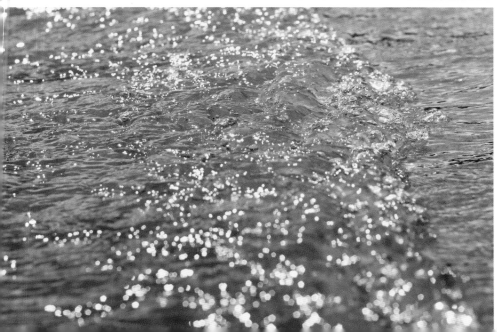

Landscape Tips and Techniques

Wide-Angle Grandeur

Shoot grand landscapes with a wide-angle lens or zoom lens with wide-angle capability to capture the breadth of a scene. A focal length range of 35mm or shorter works best.

 Purchase a wide-angle lens made especially for your phone. It will increase the field of view your phone normally captures. Newer iPhones/operating systems have a panorama feature that can be accessed through the device's native camera.

Small Aperture, Higher F-Number

Use a small aperture for broad landscapes and have a tripod to accommodate the slower shutter speeds generated. You'll most likely want to capture details throughout, which requires deep DOF. A general range of f/11 to f/22 is preferable, with the smallest apertures being best for recording the most detail. Note: I have seen some creative landscape photography purposefully created with wide apertures; try it.

If you're shooting a close-up of a subject within the landscape, the DOF will always be more shallow than if you were farther away from the subject, even at f/22.

When using a tripod to capture a landscape scene, use the lowest possible ISO setting to avoid visible noise. If you're sans tripod, bumping up the ISO might increase shutter speed enough to get a handheld shot, depending on how bright the scene is. Here's how to get that small aperture:

 Use the Landscape Scene mode, which generates a small aperture setting. If you are capturing a fast-moving subject in your landscape scene, use Sports Scene mode instead. If in P mode, you can indirectly control aperture with the program shift feature. Turn the dial to the left to decrease shutter speed and indirectly reduce the aperture size.

If you are in Aperture Priority mode or Manual mode, anywhere between f/16 and f/22 will give you the most clarity from front to back. Remember that when you get smaller than f/22, diffraction can occur, causing unwanted blur.

In Aperture Priority mode, lock in a small aperture like f/22 and dial in the lowest ISO speed possible. A slow shutter speed will most likely be generated. If you've got a tripod, embrace it. If you have a fast-moving subject in the scene, you might use Shutter Priority mode, as locking in a fast shutter speed to freeze motion will be paramount. Using Manual mode is another possibility for landscape shots. Start by dialing in a small aperture like f/18 or f/22. Select the lowest ISO speed possible and embrace the slow shutter speed that is required if you have remembered to bring along your tripod.

What if you have a wiggly subject in your landscape scene whose motion you want to freeze? Start by dialing in a faster shutter speed—try 1/250 sec. or faster. If you want to maintain detail in the background, try a smaller aperture. See what kind of ISO you would then need to bring the light meter marker to center. Make adjustments as you see fit; perhaps you decide to sacrifice some background detail and go with an aperture that's a bit wider, or maybe you go with a faster ISO speed and embrace the grain.

Composition

Think about leading lines, focal point and framing. An appealing photograph takes your eye somewhere, so look for leading lines that go to a focal point. Think about how you want to compose the shot. Perhaps you'll follow the rule of thirds or maybe you'll be more nontraditional and have mostly sky in your composition with a little bit of ground at the bottom. Most compositions work best when there is a feeling of balance.

Keep Your Horizon Straight

Most DSLRs have a grid display feature that you can use to help keep your horizon straight. Or purchase a special level that attaches to your hot shoe mount.

 You can straighten a crooked horizon in Photoshop CS/Elements or Pixlr by rotating and cropping.

 Mobile camera apps that have a built-in grid feature include Camera+, 645 Pro, Pure and 6×6. If you need to rotate your mobile photo, you can use PhotoWizard or Perspective Correct.

Avoid Distracting Elements

Telephone poles and wires, forest debris, etc., can all detract from your scene.

 You can remove some unwanted pixels in Photoshop Elements or CS with the Spot Healing Brush tool or Clone Stamp tool.

Bracketing for High Contrast

Consider using bracketing for high-contrast scenes, such as when you have a bright sky and a darker ground. Your camera's bracketing feature will take multiple shots—at dead center on the light meter and then shots that are above and below that center. You can do one of two things with bracketing. You can choose the best exposed shot from the batch or synthesize the multiple images with special High Dynamic Range (HDR) editing software to achieve a perfectly exposed scene. Photoshop (Elements and CS) has this capability.

 If you are trying to capture a high-contrast scene with an iPhone device, you can use an app like Pro HDR, which has bracketing and HDR capabilities all in one app.

Focus One-Third of the Way Into the Scene

A general rule of thumb for landscape photography is to focus one-third of the way into the scene. Use the center focus point, as it is most sensitive. If you have a subject in the landscape scene that is off to the side, choosing an AF point closest to the subject is preferable. If you are not focusing on a subject somewhere else in the scene , this method of focusing one-third of the way in is a nice alternative to the more complex technique of calculating what is known as hyperfocal distance.

Hyperfocal distance is the place in the scene you should focus on if you want to yield maximum DOF (the area of the scene that is in focus). But I have to say, all that can get mighty sticky and confusing, especially if you throw DSLR crop factors into the mix. I don't even go there myself.

Here's a simple technique you can use instead of making yourself crazy over hyperfocal distance calculations: Focus one-third of the way into the scene and depress your DOF preview button to see how much of the scene you actually got in focus. Make adjustments as you wish. Ta-da!

Use Continuous Shooting (Burst Mode)

This will ensure you get some great shots from the batch.

Use the DOF Preview Button

Your DSLR's aperture will stay in wide-open position until you press the shutter button. If you want to see what your landscape shot will look like at say f/22, press the DOF preview button and look through your viewfinder or on your LCD in Live View mode. The viewfinder preview will look darker than the actual photo.

For bonus goodies and information on this book's e-companion, visit CreateMixedMedia.com/artofeverydayphotography.

111

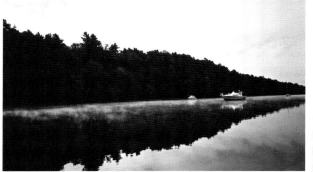

⌃ Top Left- Capture leading lines that take your eye somewhere. The diagonal line in this shot takes the viewer down the river to three boats staggered in the background, a pleasing odd-number arrangement. The sharp reflection and fog rising off the water add intrigue to the shot. 15–85mm f/3.5–5.6 lens at 21mm, ISO 100, f/14 for 1/125 sec.

⌃ I used a short focal length to capture a wide-angle view of this scene. It allowed me to record the expanse and grandeur of the vista. 15–85mm f/3.5–5.6 lens at 15mm, ISO 400, f/16 for 1/250 sec.

⌃ Top Right- Use a very small aperture for broad landscape scenes, like I did at f/22 with this shot, to ensure clarity from foreground to background. 15–85mm f/3.5–5.6 lens at 85mm, ISO 400, f/22 for 1/160 sec.

Nature Tips and Techniques

You don't have to travel far to find scenic beauty. Perhaps the flora and fauna are right outside your door. If you live in the city, go to a park or botanical garden. Long and super-long telephoto zoom lenses come in handy for photographing wildlife creatures that you can't get close to. And don't forget to seek out the tiny things. If you have a dedicated macro lens, you can experience the everyday miracles that go undetected by the naked eye.

Look for Repetition, Pattern and Color

Nature's design is nothing short of a miracle, within which you will find all of these elements. When you discover them in a way that tugs at your heart, it's definitely subject matter worthy of a shoot.

Capture Reflections

Venture outside after a rainstorm, particularly in the early morning sun. The atmosphere is bright but not overly so, and the raindrops on flora glisten like diamonds. Search for interesting reflections in the drops that cling to petals and leaves. There is pleasure in capturing a droplet just seconds before it falls to the earth.

Be a Minimalist

Extremely simple compositions that artfully use negative space to frame and accentuate a significant object can be powerful, dramatic and compelling.

Go Low

Photograph the part of the world that is normally under-foot. There is much to explore and see from this vantage point. If you have a macro lens, it's as if you shrunk yourself down amongst the flora and fauna. The fine details you can capture this way are astonishing.

Get Inside

It's preferable to use a macro lens to get inside a flower, but here's my trick for using your DSLR camera's standard lens to do so! Get as close to the subject as focusing will allow, and shoot. Bring the photo into Photoshop or Pixlr (a free program available at Pixlr.com) and crop in closer—voilà—almost like a macro lens shot! And if your DSLR has a lot of megapixels, you can crop heavily and still have what's considered to be a high-resolution image.

Make It Rain

No need to wait for the rain. An old, easy trick is to spray water droplets on your flowers with a spray bottle. They look dazzling in the sun and pick up reflections in the environment. Instead of looking down on the blooms like we normally do, change it up and get down on your belly.

Capture Falling Drops

You can freeze the motion of a raindrop or snowflake falling to the ground with a very fast shutter speed like 1/500 sec. or faster. Use a rainsleeve made especially for DSLRs, to protect your camera from the elements.

For the Love of Bugs

Bugs, bees, spiders and small creatures of the like photographed with a macro lens will open your eyes to tiny details that are not available to the naked eye. They can capture fine hairs on ant legs, dusty pollen on the fur of a bee, and allow you to count with ease the multiple glassy black eyes on a spider's head.

Cheaper, somewhat less effective alternatives include using macro extension tubes that attach to your lens and allow you to focus more closely on your tiny subject or converting your telephoto zoom lens into a zooming macro lens by attaching a close-up lens, which looks like a filter and acts like a pair of magnification reading glasses.

 Several manufacturers make macro lenses specifically for mobile devices.

Make the Light Work for You

The golden hours of morning and eve, as well as overcast days, give the best light for taking photos because it is even and soft. If you are shooting flora in bright afternoon light, place a diffuser disc above the scene to soften the light.

Golden hour backlighting illuminating your flower petals makes for glowing, ethereal, dreamy shots.

Birds and Animals

Which lens for photographing birds and animals in the wild? Use a 300mm+ telephoto zoom lens for zooming in really close to your subjects. If you can't afford one (I'm lusting after an 800mm lens that costs more than my current car), consider renting a lens or purchasing a teleconverter that you can attach to your telephoto zoom lens to lengthen it.

 You can find telephoto zoom lenses specifically for mobile devices.

Dedicated Macro Lens Tips

• If using a dedicated macro lens, the same DOF rules still apply, just on a different scale.

 If you want to blur the background, go with Portrait Scene mode or the Close-Up/Macro Scene mode. For more detail in the background, choose the Landscape Scene mode.

 If you want to capture a clear flower with a soft, blurry background, dial in a wider aperture in either Aperture Priority mode or Manual mode. If you want to take a photograph of a butterfly drinking nectar, use a small aperture like f/22 for clarity throughout.

If using your macro lens with small apertures, a tripod is a must, as the shutter speed will slow. With macro lenses, as with telephoto zoom lenses, any bit of camera shake is noticeable, so support is essential for making sharp photos.

A shutter release cable is helpful, so you don't have to jostle your camera by pressing the on-camera shutter release. The built-in self-timer may also be an option.

Specifics: In Aperture Priority or Manual mode, dial in your desired aperture. If you want clarity from front to back, dial in anywhere from f/16 to f/22. Set the ISO as low as possible and go with the slower shutter speed required for proper exposure, with your camera mounted on a tripod. If it is windy, or you don't have your tripod, choose a wider aperture and higher ISO, both of which will yield a faster shutter speed that prevents blur from either camera shake or subject blur.

• Use a shutter speed of at least 1/250 sec. on windy days to freeze the motion of your macro subject. When you're up close, any motion caused by the wind looks strong through the lens. My advice: Don't shoot macro on windy days. It's no fun.

• Turn off autofocus. In most cases your DSLR won't be able to hone in on your subject, so try using manual focusing instead.

• Shooting with a macro lens can be tricky, as any shadows or darker areas will look like giant potholes in the actual photos. Look for clean backgrounds.

 You can use Photoshop's Clone Stamp tool and/or Spot Healing Brush tool to get rid of them.

• Ring flashes work well for macro photography, as they cast soft, even light throughout your scene and often get rid of those nasty potholes in the background. They also help to freeze motion when there is wind.

 If you don't have a dedicated macro lens for taking close-up shots, use your DSLR's Close-Up/Macro Scene mode. It works especially well with a zoom lens. Keep in mind you won't be able to get as close as you would with a macro lens.

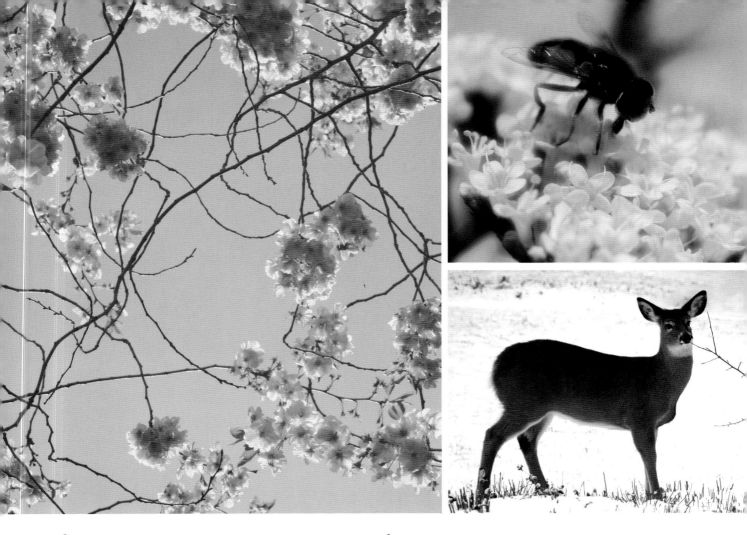

⌃⌃ I spotted these cherry trees in the city of Portland, Maine. The soft pink petals were in stark contrast to the tangle of branches they grew off of, making for a stunning shot that to me symbolized the transition from a harsh Maine winter into a softer spring. I altered this photo with several actions from MCP Actions' Spring Splendor set. 15–85mm f/3.5–5.6 lens at 70mm, ISO 100, f/11 for 1/160 sec.

⌃⌃ Top Right - When shooting with a dedicated macro lens, the same DOF rules apply, just on a smaller scale. An aperture setting of f/5 gave me a clear foreground and soft, blurry background in this macro shot. The back of the honeybee recedes into the blur, which I like. If I wanted the entire bee to be clear, I would have chosen a smaller aperture. 100mm f/2.8 lens, ISO 100, f/5.0 for 1/1000 sec.

⌃⌃ Bottom Right - It was the morning of the season's first snow when the deer came out of the woods to eat the remains of our flower and vegetable gardens. I quickly attached my 300mm telephoto zoom lens and was privileged enough to capture a close-up photograph of one of the younger, less cautious does. I kept my shutter speed fast, ready to capture a running or leaping deer. 75–300mm f/4–5.6 lens at 90mm, ISO 200, f/4 for 1/800 sec.

For bonus goodies and information on this book's e-companion, visit CreateMixedMedia.com/artofeverydayphotography.

115

Capturing Landscape and Nature With Mobile Devices

Photography Tips by Daniel Berman and Melissa Vincent

Both Daniel Berman and Melissa Vincent, well-known artists in the mobile photography world, take stellar mobile shots of landscapes and nature. They share their favorite apps and top tips.

Favorite Lens Attachments

Daniel » The olloclip because it's so small, light and easy to use. Their macro lens gives very pleasing results.

Melissa » The olloclip and Photojojo macro attachment lenses inspire me to shoot on a daily basis. I have a cell science degree, so looking at things up close and in different ways has always been something that has piqued my interest.

Go-To Apps

Daniel » Right now . . . Snapseed, VSCO Cam, Filterstorm, Blender, Handy Photo, Photo fx.

Melissa » They are constantly changing, but right now I like Repix, Superimpose, Elasticam and Facetune.

⌄ *Alan and the Goose* - "This mobile shot was taken on a very early spring day not long after the pond had melted. Alan had a moment with the goose." —Daniel Berman

⌄ *Sundown for Jim James* - "I have a series of sundown images taken at the local millpond, and I name each one in honor of a favorite musician." —Daniel Berman

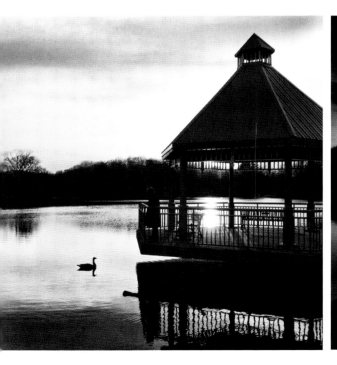

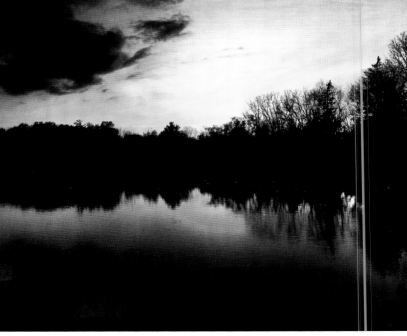

⌃ *Wishes* - "Nothing makes me feel more like a child again than blowing dandelion seeds. When I saw this one on a hot summer day, I knew I had to capture it with my iPhone and olloclip macro lens. It's a photo of wishes yet to be wished." —Melissa Vincent

⌃ *New Beginnings* - "Spring is one of my favorite seasons because of the new life it brings. This photo of a pink bud just about to burst open made me pause and take a shot with my iPhone and olloclip macro lens. It illustrates the innocence, youth and hope that so aptly brings to mind the spring season." —Melissa Vincent

Daniel's Top Tips

- In landscape photography, when you shoot is as important as what you shoot. Early in the morning and prior to sunset are the landscape photographer's favorite times of day. The light is softer and casts a glow upon the land that is fleeting, ethereal and golden.

- Look for points of interest in the landscape like animals, a solitary tree in a field or water reflecting the sunset. Be creative and keep your eyes open!

- Use the form factor of the phone itself to create unique shots. Go places up high and down low for shots not easily possible with a bigger camera.

Melissa's Mobile Macro Tips

- Take outdoor photos on days without wind. Your subject has to be still to achieve a crisp shot.

- Experiment by taking shots of all kinds of things in nature and in your daily life. You will be surprised how amazing ordinary things look up close.

- Keep a steady hand. Setting your smartphone on a tripod is one way to eliminate movement, but for shots in nature you will usually need to practice getting close to the subject while keeping your hand as still as possible. Use both hands to reduce motion.

For bonus goodies and information on this book's e-companion, visit CreateMixedMedia.com/artofeverydayphotography.

117

Everyday Life & TRAVEL Photography

I tend to think of the act of photographing, generally speaking, as an adventure. My favorite thing is to go where I've never been.

» Diane Arbus

We all want to be happy. Many of us want to lead adventurous lives. All of us at some point have said things like, "If only I had. . . ." or "Someday when I have more time, money, etc." or "I'll be happy when . . ." And why is it that so many of us feel like happiness, excitement and adventure are out of reach, fleeting or maybe even impossible to obtain? Maybe it has to do with the way we define these things.

What if there were to be a shift in our perceptions and the way we choose to define happiness for ourselves, not measuring it against other lofty standards? And what if the key to finding it existed within ourselves as opposed to somewhere out there?

One of the blessings photography has brought into my life is that it has shifted my perceptions of happiness, adventure and what it means to live life to the fullest. I have learned that having a happy life is not so much about having big moments and traveling the world, although some more travel would be nice, but more about appreciating the smaller, everyday moments in between.

When we photograph daily life and go on photo adventures in our own backyards and towns, we begin to see our lives differently: We see more beauty that we wish to capture through our lens, we notice details that before went unnoticed, and we feel our own beauty bubble up inside when we see something that moves us. We start to feel more gratitude for what we have, we feel more connected to and more present in our lives, and we wind up attracting even more beauty, adventure and celebration into our lives! So what are you waiting for? Pick up that camera and go!

⌃ "When composing a photo I'm always looking for interesting details and lines. I love the muted tones and seemingly chaotic order of these old printing stamps."
—Susannah Conway

⌃ "I'm in love with light and I've found that shooting water is a fun and fascinating way to study light. Working with a shallow depth of field brings even more magic to light and liquid." — Tracey Clark

Your Amazing Everyday Life

I believe that there is extraordinary to be found in the ordinary, and that we can elevate our everyday lives by embracing and honoring that which is simple. I invite you to capture the everyday in your photography. Look for the finer details. The following ideas explain how.

An Aspect of a Morning Ritual

Maybe you greet the day with a cup of tea or coffee, the newspaper, journal writing, blog surfing or stirring a pot of your favorite Irish oatmeal. Use the soft, diffused natural morning light that comes through a window in your home to illuminate your subject. How do you want the light to hit your subject: as backlighting, at an angle or as front lighting? If the light is coming from the front, make sure the subject is far enough away from the window so it does not get washed out by harsh direct light.

Something You Want to Remember

My daughter has a favorite pair of socks that just barely fit her at this point. She often wore them with her favorite striped dress—an outfit that captures her free spirit. I took a photograph of her wearing these garments because I always want to be reminded of her free spirit when I look back on her childhood.

Your Road or Block

As time goes on, the landscape changes, often dramatically. If you live in the country, trees grow, old barns fall, people build. In the city, your favorite shops and eateries are often transient. I lived in Boston in my twenties and the amount of transformation my old neighborhood has seen since then is pretty remarkable. Make photos of the significant places you want to remember: your favorite bookstore, cafe, coffee shop, gallery or tree-lined street.

Elevate Your Errands to Art

Some ideas: a photo of a shopping cart in the rain, the artfully displayed artisan bread at the bakery, fresh catches of the day on ice at the local fish market, jams and jellies on a shelf at the farmer's market.

For bonus goodies and information on this book's e-companion, visit CreateMixedMedia.com/artofeverydayphotography.

119

Look Up

Capture blue skies, sunsets, stormy and overcast skies and cloud formations.

 It's fun to tweak the colors a bit in Photoshop CS/Elements or Pixlr. Adjust the hue slider a bit— think subtle change.

 Mobile apps that offer color-altering filters include Camera+, AfterLight and iColorama S.

That Which Nourishes You

Is it food? Art? Running? Playing a musical instrument? Whatever it is, use your lens to capture what feeds your soul. My family and I have been growing our passion of homesteading—gardening, preserving food, developing the prospect of keeping small livestock. I enjoy taking photographs in honor of this unfolding passion and way of life.

Look for Hidden Minute Details

When you look through a window, are you seeing what lies beyond the pane or noticing the minute flaws on the glass—the fingerprints, dirt and grit, dried rivulets, raindrops and the like? Instead of looking beyond at what you think deserves your most attention, look at the finer, up-close details that tend to go unnoticed—those nighttime raindrops on the windshield illuminated by streetlights, the lipstick stains on your anniversary celebration wine glass.

« "I was so thrilled to see the blossoms after a long and tiring winter, so the addition of the blue sky and painted houses made for an incredibly happy shot." —Susannah Conway

Give focus to these details and blur the subject matter that the viewer expects to see in focus. Selecting a wider aperture is best, as it will provide a soft, blurry background and direct the viewer's eye to the close-up details. Be sure to switch your lens to manual focus and turn the focal ring until you find focus. In autofocus your lens will search and search and possibly lock focus on the wrong part of the scene.

Portraits of Body Parts

What attracts you to a loved one? Is it their eyes? Hands? The wrinkles in their forehead (such beautiful imprints of their gorgeous mind and thoughts)? Or maybe it is the way their hair falls just past their shoulders. Whatever it is that you love about someone—those physical traits that symbolize something deeper, some aspect of their soul— capture and honor them with your lens.

Significant Objects in Your Home

Walk around your house. What objects are special to you? What are your keepsakes? What makes this place feel like home? Open your door to the outside world. Stand on your stoop. What do you see? Hear? Take it in through your lens. Walk around your property or your neighborhood. Imagine that you have a pen pal in a foreign country and you want to show them your place. Capture what you love about your surroundings.

Your Favorite Meal

What do you love to eat? Share it through photographs. Use attractive dishware and plate it beautifully. Set up a pleasing still-life scene and take some shots from different vantage points. Then enjoy your food.

Shoot Objects as Abstracts

Shoot an everyday object close-up, transforming the object into an abstract work of art, bringing into light its finer details that would normally go unnoticed.

The Art of the Everyday

Tips From Tracey Clark and Susannah Conway

Both Tracey Clark and Susannah Conway have talents for capturing the everyday in their photographs and elevating them to the level of art. They have generously shared not only some of their beautiful photographs with us, but also their favorite tips for taking stunning photographs of everyday life.

Tracey Clark's Tips

"Capturing everyday moments through my lens helps to remind me of the magic of my everyday life. I try to seek out the beauty, wonder and even mystery in the seemingly most mundane part of daily life. Photographing my everyday life means first seeing it and then shooting it in a way that makes me feel grateful and grounded.

"There are a few simple techniques I keep in mind as I focus on my everyday moments."

Show a Uniquely Fresh Perspective

"The way you take your shot—the angle you choose to shoot it—can make all the difference in improving your photography. Get low and shoot up. Get tall and shoot down. Tilt your camera when you click the shutter. All you need is a little something out of the ordinary to get more extraordinary shots of everyday life." —Tracey

Look for the Light

"Beautiful light can make anything look amazing. Learning how light works to highlight and define your subject matter is probably the most useful thing you can learn in photography." —Tracey

Capture Something Unexpected

"When documenting images of everyday life, try shooting something that might normally be overlooked or unseen. Taking a shot that is somewhat unexpected is what elevates a snapshot into something more artful and compelling." —Tracey

Susannah Conway's Tips

"For me a camera is a meditative tool, an extension of my own eyes that provides a way to observe and record my world and the moments I want to cherish."

Keep Your Eyes Open and Stay Curious

"It's easy to take photographs when something special is happening, but examine the in-between moments too." —Susannah

Look for Lines and Shapes

"Search out pattern and color. Pay attention to the light. How does it change in your house throughout the day?" —Susannah

Get Closer

"That wall you walk past every day to work? The old tree you've seen hundreds of times but never touched? What magic can you find there when you look through the lens?" —Susannah

"Photographing my meals with my iPhone is a standard part of my day — breakfast lends itself particularly well to this practice! It's such a great way to hone your still-life skills." —Susannah Conway

⌃ "Rarely do I get the opportunity to shoot photos of my own children at formal events. My youngest daughter was in a family wedding that I wasn't shooting, so I got to pull her away from the festivities for a while and play with her (and my camera). It was such a treat!" —Tracey Clark

⌃ Top Right - "London is full of colour and dirt and this shot sums that up for me. I'm always looking for the quirky parts of my environment that often get overlooked." —Susannah Conway

⌃ "This vibrant wall was the perfect backdrop for a quick snap of my friend. The fact that her outfit's so neutral makes the image even more interesting to me." —Susannah Conway

122

The Story of Your Travels

Your travels, whether to a nearby town for the day, a weekend getaway or a trip to Paris, are perfect opportunities for taking creative, unique photographs.

I invite you to stay away from postcard-style pictures of landmarks and monuments and the full smile, stiff poses in front of them. Instead, think of your photography as capturing the story of your journey and the finer details that you notice all around you. Think of street photography as taking photos of how you yourself perceive the environment. What are you drawn to? What moves you?

You can learn a lot about yourself as well as a particular place, as you explore this type of photography, discovering the beauty of everyday life and the beauty in you.

Gear to Pack

Pair down to absolute essentials. I generally take one telephoto zoom lens that provides versatility—I bring my 15–85mm f/3.5–5.6 lens. It has wide-angle capability, as well as the ability to create shallow DOF. The wide-angle capability is perfect for taking photos of architecture.

If you are going to be out and about photographing over a long period of time, it might be a good idea to invest in a comfy, sturdy neckstrap to help prevent neck and shoulder pain, especially if you have a weighty lens. You also might want a waterproof camera bag and a special DSLR rainsleeve to protect your camera from the elements.

Ideas for Candids of People

People-Watch

Plant yourself at a cafe table, street corner or a bustling local spot like a farmer's market, and watch people at work and play. Observe as they communicate with one another and photograph these connections and exchanges. The subjects are so involved with what they are doing and one another, chances are you can remain invisible.

Look for Emotions and Body Gestures

Seek expressions of love, passion, sadness, joy, etc.

Look for Engagement in Communal Activities

Neighborhood basketball games, craft fairs, carnivals, flea markets or yard sales are all prime spots. Capture street performers entertaining a crowd, people picnicking and playing at a public park or runners and spectators at a 5K race.

Photograph Interesting Body Parts

Consider photographing an interesting part of someone's body. Maybe a leg covered in an artful tattoo, a picture of braided hair or dreads going down their back, or a couple's hands intertwined together as they stroll down the street.

Change Up the Perspective

Photograph people at an angle, from behind, from an elevation looking down or from the bottom of a hill looking up. Place your camera on the ground and photograph the feet and legs of passersby. We are always looking at things in front of us—why not turn around and see what's behind you that might be worthy of a shot?

Think About Light

Even light is the easiest to work with and works well for street photography when you need to snap pictures quickly, without much thought to settings. Look for overcast light, front lighting (although flat, casts a nice even light during the golden hours) and shady spots without dappled light. Also consider composition/framing (a Rules of Composition Toolkit is included in the e-companion to this book. Visit CreateMixedMedia.com/artofeverydayphotography to learn more).

Don't Forget Selfies

Remember to take some selfie portraits and photos of the folks you are traveling with. Look for unique settings for your portraits: a window seat in a coffee shop (capture a friend gazing out the window) or through a frame of tree branches. Photograph your loved one window-shopping or indulging in a treat, trying on clothes or costumes or toasting over a meal.

For bonus goodies and information on this book's e-companion, visit CreateMixedMedia.com/artofeverydayphotography.

123

Ideas for Capturing the More Inanimate

Look for the Finer Details

What's underfoot? Maybe cobblestone, reflections in puddles, fallen leaves. Look for the remnants, the discards and found objects; it doesn't always have to be pretty, just real. Have a friend with rooftop access? An excellent vantage point for photos. If not, use the parking garage top floor or hotel rooftop lounge/restaurant, or go to the public observatory of an historic building.

Look for Still-Life Scenes to Capture

Market stalls, bakery displays, flea market wares, the food and drink you eat, parked bicycles, flowers in a vase at dinner, chandeliers, candles, street debris, restaurant interiors, signs . . . to give you some ideas.

Seek Reflections

Window-shop looking for fascinating reflections of yourself, your companions, architecture behind you, trees, lampposts, etc. Once you find an appealing one, try framing the photograph from an angle where the reflection melds nicely with the elements in the window.

Capture Flora and Fauna

Public gardens, window boxes, trees, flowers for sale, all make terrific subject matter. In urban settings, fauna may be more sparse, but don't overlook hidden gems.

Create Interesting Compositions

Look for interesting shapes, patterns and unique juxtapositions. Power lines, especially ones that serve large populations, can be a lot of fun to photograph.

Photograph Entrances to Dwellings

Antique entrances in particular have such character. And the viewer is led to wonder what is behind the door.

My longtime friend and talented photographer, Susanna Gordon, always has fantastic ideas when it comes to shooting creatively. We've been on several photowalks together, and I have learned a lot about what to photograph by observing her.

Susanna's Hot Tips for Travel

Shoot With a Theme in Mind

"Sometimes it's easy to be inspired by what we see in the world, particularly while traveling or participating in a special event. At other times, however, it can be challenging. I've had days where I've walked through the city for hours, only taking ten images, none of which I liked later.

"A helpful tip for "photo block" is to look for themes like interesting fashions, window displays, reflections or shadows."

Shoot a Lot

"You'll have more images to choose from later and the odds are that one of the images will be spot-on sharp." —Susanna

Do Not Delete Photos In-Camera

"Rather, delete after you've uploaded your images onto your computer. Shots you might have deleted could end up being your favorites." —Susanna

Susan's DSLR Tips

- Candids usually involve people moving and on the go! So don't forget to draw upon skills you now have. Use Continuous Focus mode to ensure clear focus of a moving subject.

- P mode is my favorite mode for spontaneous street photography. This type of photography demands that you be able to snap the shutter button at the drop of a hat. Let the camera take care of your settings for you when it comes to in-the-moment street photography. I often use P mode in conjunction with a high ISO to make sure the shutter speed stays fast enough for clear street shots. Of course, the high ISO results in graininess, which in this case I embrace and call creative film grain. The grain looks especially good and even gets enhanced when converted to black and white.

- For obvious reasons, turn the flash off when it comes to street photography candids of strangers.

- When taking shots of architecture, go out of P mode and choose a shorter focal length and a smaller aperture, anywhere from f/16 to f/22. These two things will allow you to capture detail in the full breadth of an architectural structure. Specifics: In Aperture Priority mode, lock in a small aperture like f/22. Select an ISO speed that's a good match for the light in the scene. Observe what shutter speed the camera selects. If it's too slow, use a tripod, or increase ISO to get the faster shutter speed necessary for a handheld shot. In Manual mode, dial in a small aperture to start with (try f/22). Select an ISO that matches the light in the scene. Dial in a shutter speed that brings the light meter marker to center. If the shutter speed is too slow for a handheld shot, use a tripod or swap out a stop of shutter speed for a stop of ISO or aperture.

- Don't be afraid of bad weather. If it's a cloudy day, set your ISO to somewhere between 400 and 800, and set your white balance to the Cloudy setting. Grand architectural structures can look magnificent set against a sky of brewing storm clouds.

- The weather and intensity/location/direction of light will change throughout the course of your travels. Remember to utilize your white balance settings to achieve more natural, truer colors in special lighting conditions.

- Use appropriate ISO settings (think low speed for bright light and high for poor lighting). A few tools can come in handy, like spot metering when you have bright light behind a subject and want to make sure their front is well exposed. Think about what type of DOF you would like—shallow DOF for a close-up object? Deep DOF for a landscape shot? When taking photos of the street performer juggling, do you want to freeze the motion with a fast speed or blur it with a slower one?

To Be Inconspicuous

To be inconspicuous is not as tricky as you might think. A long lens is your friend, as it allows you to shoot from a distance. Do not look at the subject, but pretend to be taking pictures of something behind them or in their vicinity. If they are not looking at you, chances are you can safely get the shot without being noticed. Also, if the subject is engaged in an activity, their focus will be on their task instead of you—perfect opportunity for a great candid!

A Mobile Phone Can Render You Invisible

A smartphone is your best bet for street photography candids. Folks think you are texting, checking your e-mail or surfing the Net. They have no idea you are taking street photos of them. And be sure to turn off your phone's sound to ensure invisibility.

For bonus goodies and information on this book's e-companion, visit CreateMixedMedia.com/artofeverydayphotography.

125

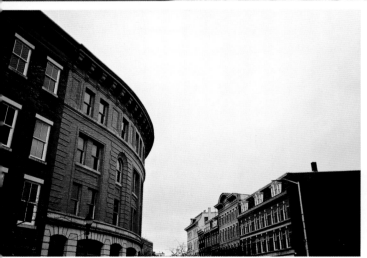

⌃ A wide-angle lens/focal length allows you to capture the full breadth of an architectural structure. In this shot, the short focal length gives a wide angle of view in addition to an almost fisheye-lens-type of warped appearance. 15–85mm f/3.5–5.6 lens at 17mm, ISO 200, f/10 for 1/160 sec.

⌃ Some travels are all about the scenic drive. Don't forget to bring your camera along and pull over often to capture the beauty along the way. 15–85mm f/3.5–5.6 lens at 17mm, ISO 200, f/5.6 for 1/100 sec.

« Opposite Page, Top - Look for signs or colorful graffiti to capture as you explore a city. Susanna Gordon took this shot in Toronto, near her home, using a wide-angle focal length to ensure she captured all significant parts of the scene. 18–135mm f/3.5–5.6 lens at 18mm, ISO 400, f/5.6 for 1/250 sec.

« "There was something timeless about this scene. Not in the clothes she wore but in the way she stood. Graceful. Honestly, I didn't worry about the technical setup as I had to be quick—the subway train was coming!" —Susanna Gordon. 18–135mm f/3.5–5.6 lens at 75mm, ISO 1600, f/5.3 for 1/20 sec.

« I wanted to remember this special date with my honey, indulging on oysters and a bottle of French wine. The reflective glass and candlelight made the image special, and the incredibly high ISO (go with the grain!) allowed me to get this indoor, very low-light shot handheld without a flash (evidence of my ability to hold very still). 15-85mm f/3.5-5.6 lens at 15mm, ISO 2500, f/4 for 1/20 sec. with image stabilization.

Mobile Street Photography Masters

Advice From Christina Nørdam Andersen, Thomas Kakareko and Dilshad Corleone

> " I find mobile photography appealing due to its spontaneous and unpretentious nature. Taking photos with my iPhone allows me to express myself, and I consider my photos to be a visual diary of my emotions, dreams and desires.
> » Christina Nørdam Andersen

Mobile phone cameras have taken street photography to a whole new level; the devices are portable, small and easy to handle, and render the photographer virtually invisible, allowing for more authentic, compelling captures. Let's talk mobile street photography, one of the most popular forms of smartphone photography, with three stellar artists whose work is very well known and admired in the mobile photography world: Christina Nørdam Andersen, Thomas Kakareko and Dilshad Corleone.

Christina's Advice

My first advice is to keenly observe your surroundings and keep an open mind for what you might find. Be susceptible to what is in front of you and allow yourself to submerge into the scene emotionally. When something or someone interesting catches your eye, consider the composition of the photo—how the background and perspective can contribute to the story you wish to tell with your photo. A tip of a more practical nature is to keep your mobile camera open and ready to shoot in your hands, ready for when that shoot might present itself to you. Discretion is key in street photography and I find that it is helpful to observe your subject through the mobile phone screen rather than establish eye contact. My motto is: Shoot first and think later.

Thomas's Advice

You should always keep your lens clean. I had to delete so many great photos because of this issue. Be sure to carry an additional battery pack with you. You will regret it if you find an interesting moment and your phone just dies. But mainly you should just try to enjoy the whole process of taking street photos. Even after almost three years of shooting in Berlin, I still keep finding places that I've never been to before. Keep smiling and shoot away.

Dilshad's Tips

- Don't be afraid or timid. Get as close to your subject as possible. You are not doing anything wrong.

- Keep looking, observe and take your time doing this, all the time. There are so many opportunities that one can miss by just "switching off," so always be alert.

- Find what you like, shoot when you feel. There will be moments when you think, *I'll do it later* or *I cannot reach my phone/camera just now*. Well, then you may have just missed some great photos. So shoot, shoot and shoot and do it with you heart and your gut!

- Look for the light, play with it and create silhouettes of people.

 And when you see a character that you want to snap, be creative, fake a phone call, talk louder so that they can hear you, and keep getting closer. Once you are close enough, tell your imaginary friend that you are checking your messages and will put them on hold for one second. At that point you can start snapping to your heart's content! (You might want to turn the sound off.)

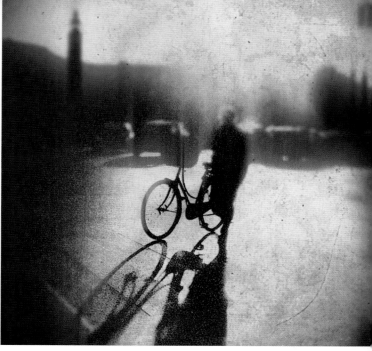

⌃ *Never Let Me Go* - "I followed the girl into the mist, which creates a beautiful and surreal backdrop. I like capturing those rare moments when people lose their self-consciousness." —Christina Nørdam Andersen

⌃ *Another State of Mind* - "I remember being in a particular state of mind when I took this photo and I tried to translate my feelings into the edit. I played with focus and contrasts—using the Focusoid app to apply blur, Noir to create the contrast, and Lo-Mob to add the analogue effect." —Christina Nørdam Andersen

Favorite Apps

Christina

Noir is my go-to app. I like that it is a fairly simple app that can be used to create excellent classic-looking monochromes. It's easy to use with few controls that give you a great degree of control. There are three dials for contrast, outer exposure and inner exposure. You can also add a vignette effect exactly where you want to and thereby draw attention to one element of the photo. Snapseed is another favorite app that I highly recommend as an all-around app. It has many powerful photo-correction tools, localized adjustments and many enhancing effects/filters such as Drama, Grunge, Vintage, Center Focus, Frames and Tilt Shift. I would like to highlight the VSCO Cam app, which offers several predefined effects for both black-and-white and color photos. The beautiful effects emulate the emulsions and grains of real 35mm film brands like Kodak, Fuji and Ilford.

Thomas

During the last three years, I have probably tried them all out. I've been experimenting a lot and always use many apps to reach the desired effect. When I first started taking mobile photos I used Hipstamatic, but after a while I started to get bored and wanted to have more control over my pictures. My next obsession was Filterstorm, with its endless editing possibilities. But there's only one app I truly fell in love with, and that is Noir. It's perfect for vignetting and I love the black-and-white tones it produces. Today I mainly work with Snapseed and VSCO Cam because they are powerful and easy to use.

Dilshad

I'm trying to go minimal, so at the moment I'm keeping it very basic and using Snapseed a lot. Oggl, an app from Hipstamatic, is also playing an important part in my photography lately. So these two would be my very favorite at this point in time, but it will all change soon, I know it.

For bonus goodies and information on this book's e-companion, visit CreateMixedMedia.com/artofeverydayphotography.

129

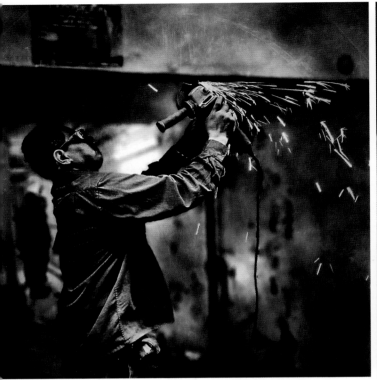

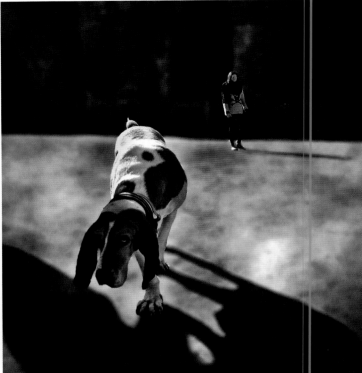

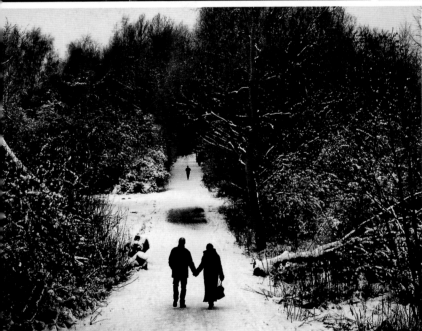

⌃ "Mobile photography is the easiest and still most rewarding way for me to do what I love. I want to capture real emotions and expressions and my iPhone is my tool."
—Thomas Kakareko

⌃ "Thanks to mobile photography I finally found a way to express myself in a creative way."
—Thomas Kakareko

« Opposite Page, Top Left - "I knew there was something here. All those sparks; I just wanted to catch it!" —Dilshad Corleone

« Opposite Page, Top Right-"This was shot in Barcelona in an open-space park without grass, where dogs and their owners walk freely. I remember this dog was interested in what I was doing and came to check if I had snapped him to his liking." —Dilshad Corleone

Mobile Photo Wall of Fame

An Instagram Contest

One of the joys of mobile photography is that people from all walks of life all around the globe can take a photograph of something that is meaningful to them, edit it in a creative way and share it with the world in seconds via a social network like Instagram (IG). I held a contest on IG, asking folks to share their favorite photographs. The response was incredible, with over 2,200 entries. I wish I could share every single one, but it would fill this book and then some. Turn the page to see the winners!

Row 1 » Ade Santora (adesantora) | Alexander Castillo (snoflak) | Allyson Simes (asherahamor) | Alon Goldsmith (alon_goldsmith) | Ana Cuk (ana_cuk) | Arijana Gurdon (ari55) | Chris Hawkins (cjhawkins.net) | Crystal Faith Spellman (faithmichael)

Row 2 » Darby Casey (darbycasey) | Francesco Morleo (framorleo) | Gabriela Mateus (gmateus) | Gary Edward Blum (garyedwardblum) | Ian Dennis (densf) | Ivana J. Bucci (ivajo_) | Jane Fiala (jlfiala)

Row 3 » Jennifer Burnett (jenburnett) | Jim Cook (jcook) | Joshua Anderson (imapirate1) | Kelly Kardos (kellykardos) | Maria Flourou (muzbanger) | Michael Kovalik (michaelkovalik) | Michael Koralewski (michal_koralewski)

Row 4 » Molly Hodges (molly_h13) | Nabi Kircaoglu (nabikirc) | Naimah Gibbons (naimah) | Nicholas Hensler (lifefiltered) | Rebecca Cornwell (repinsk) | Rhonda Brynko (preciousnest) | Rob Pearson-Wright (Flickr: brian_beaver) | Sandi Pfeifer (Flickr: Sandi3391)

Row 5 » Sara Tune (tune_omatic) | Sharon Kim (sharonkim_) | Sigrún Sigurðardóttir (runsi3) | Simon J. Webb (fiireman) | Spring H. Lowe (springheather) | Victoria Plaza (vitoriapordios_) | Wayman Stairs (wstairs)

For bonus goodies and information on this book's e-companion, visit CreateMixedMedia.com/artofeverydayphotography.

131

Life Celebrations

Be sure to celebrate the everyday gifts and blessings as well as the monumental occasions. Oprah Winfrey puts it best: "The more you praise and celebrate your life, the more there is in life to celebrate."

And I will add something to that. The art and act of photographing your life will open your eyes to all of the everyday reasons to celebrate and will invite even more of these special moments into your life.

Everyday Celebratory Moments

Childhood

Playing, sleeping, exploring nature, crawling in the grass, climbing a favorite tree, playing a sport, baking or cooking with a family member, picking apples, getting on the school bus—there are so many daily celebrations to capture. Consider taking a series of shots to tell the story.

 You might even want to use the Collage feature in Pixlr's Express editor to present the photos (pixlr.com).

 There are also some iPhoneography collage apps with appealing templates—try Mosaiq and Diptic.

Achievements

Celebrate accomplishments—the big, the small and everything in between. Capture family and friends in their special moments—dance and music recitals, sporting events, the building of a home, climbing a mountain, a young couple's first Thanksgiving turkey, running a race, a baby taking her first steps, an art show, last or first day of school, graduation, reading a book for the first time, cutting or losing a first tooth, removing the training wheels and going for a ride, getting a car license, etc.

Passions

Take photos of someone doing what they love in life—playing a musical instrument, making art, sailing, fishing, hunting, doing puzzles, running, gardening, cooking, taking photos (yes, don't forget to have someone photograph you engaging in your passion), reading, sewing, fencing, whatever the passion happens to be.

Love!

For a spouse, child, parent, grandparent, friend, animal Shots of love are filled with energy you can feel! These snippets are so fun to photograph and mega-fun to photo-manipulate.

Night Light

December is a great time for photographing holiday light displays, flickering candles and fires in the hearth. You might want to capture some bokeh while you're at it. Use manual focusing to achieve this, turning the focus ring until you see those holiday lights transform into beautiful, soft, abstract dots of light in your viewfinder. Be sure to switch your lens to Manual Focus mode, as this maneuver can damage some lenses in Autofocus mode.

Take photos of glowing jack-o-lanterns at Halloween. And what about the Fourth of July fireworks? (See the how-to for fireworks in the Creative Camera Model for Shooting in Manual section in Chapter Two.) Don't forget to bring along your tripod to accommodate those slower shutter speeds.

Since photographing life celebrations calls for a variety of appropriate apertures and shutter speeds, depending on the scenario, I've decided to give you a quick reference list.

Aperture Reminders

Single Subject Portraits

 Use the Portrait Scene mode for a soft, blurred background.

Group Portraits

When folks are staggered, a range of f/8 to f/11 is recommended to ensure everyone is in focus. In P mode, you can indirectly manipulate aperture by increasing or decreasing shutter speed with the program shift feature. To obtain a smaller aperture, just decrease the shutter speed by simply turning the dial on the top of your DSLR to the left.

Landscape Subjects

Use the Landscape Scene mode for clarity from front to back in the scene.

Single Subject Portraits With Shallow DOF

 Use roughly f/4 or wider. Wider than f/2.8 can cause facial blur.

Single Subject Portraits With Greater DOF

Generally f/5.6 to f/11 is a good range.

Group Portraits

A range of f/8 to f/11 will ensure everyone is in focus.

Landscape Subjects

A general range of f/11 to f/22 is preferable for capturing detail from front to back in a landscape scene. Keep in mind that the closer you are to your subject, the more the blurred the background will be, even at f/22.

Shutter Speed Reminders

To Freeze Motion

 Use the Sports Scene mode.

To Blur Motion

In P mode use the program shift feature to override the camera's shutter speed choice. Flip the dial to the left to choose a slower shutter speed. Use a tripod to prevent blur from camera shake.

To Freeze Motion

 If taking a shot of a still person, you might be able to get away with 1/60 sec. To play it safe and when taking photos of subjects who are relatively still, a range of 1/125 sec. to 1/250 sec. is ideal, with 1/250 sec. ensuring crisper shots. When you see movement, you'll need 1/250 sec. or faster to freeze it. For fast action shots of people, 1/500 sec. is more than sufficient.

To Blur Motion

Use 1/60 sec. or slower. If you want to use the panning technique, consult the Semiautomatic Exposure Modes section in Chapter Two for a how-to refresher.

iPhoneography Apps for Long Exposure Photography

 If you want to capture fireworks or sparkling holiday lights at night with your smartphone, here are some mobile apps to try:

LightBomber (Tip: If using this app, be sure to sign up for an account via the app before taking photos—it's the only way you can save the photos you take. Unfortunately I learned this the hard way.), Slow Shutter Cam and LongExpo.

For bonus goodies and information on this book's e-companion, visit CreateMixedMedia.com/artofeverydayphotography.

135

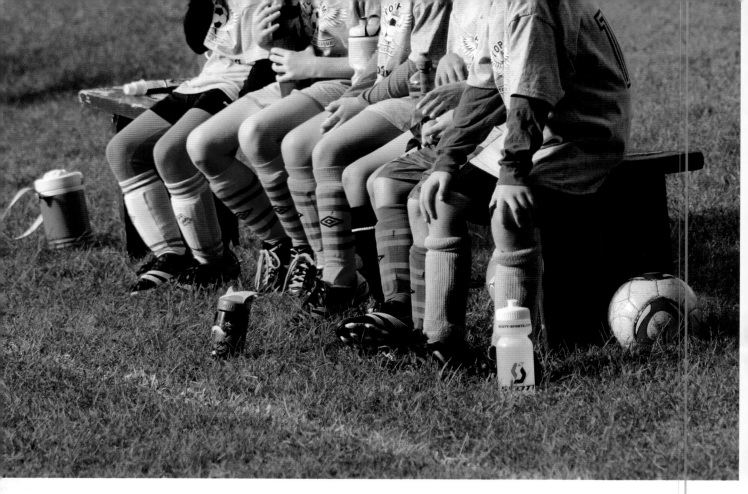

⌃ The first youth soccer game of the season means bright and shiny new uniforms, shinguards and cleats. I spotted this eye-catching composition of the kiddos all lined up in a colorful row. 75–300mm f/4–5.6 lens at 200mm, ISO 200, f/6.3 for 1/250 sec.

» Opposite Page, Top Left - Celebrate the tastes of autumn with apple orchard shots. Lucky me the rule of odds occurred by happenstance here; remember that the eye prefers to see an odd number of objects, as opposed to even. 50mm f/1.8 lens, ISO 100, f/2.8 for 1/400 sec.

DSLR Tips

When taking photographs at, say, a wedding or birthday party, there are moments you don't want to miss. These moments often happen fast amongst a flurry of movement, so you need to be ready.

- Set your DSLR to Continuous Focus mode if your subjects are moving around a lot. This way your camera will continually focus, allowing you to avoid shutter lag and thus missed shots.

- Consider shooting in P mode, allowing the camera to make decisions for you. You don't want to miss the shot because you were fussing over settings. Another recom-

mendation is to set the ISO high so the shutter speed will always be fast enough for a handheld shot. Embrace the creative grain that a high ISO can produce! Grainy shots often look attractive after applying a filter in CameraBag.

- Put your camera in Continuous Shooting mode (Burst mode). Get lots of shots to choose from!

- If you're in a low-light situation, flash is always an option. A powered-down external flash unit can provide natural results. If you must use the built-in flash, know that modern DSLR flash units can be powered-down.

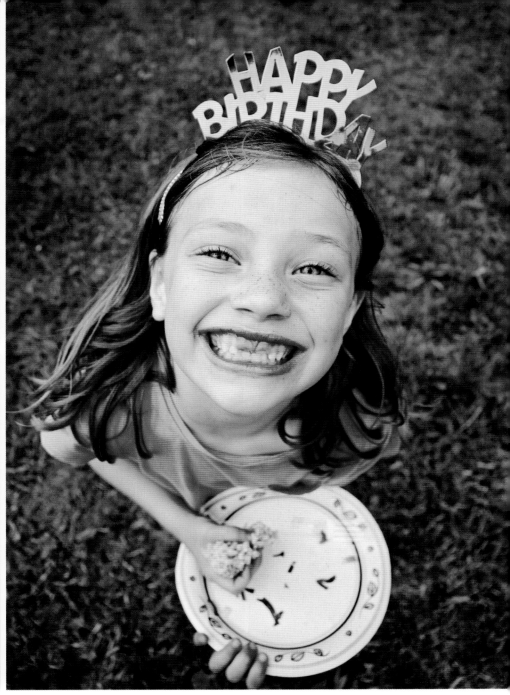

My town celebrates its birthday each year with a fair and finishes off the event with a spectacular fireworks show. Don't these look like dragonflies? 50mm f/1.8 lens, ISO 100, f/8, bulb for a few seconds (taken with a tripod, of course).

Very wide-angle lens shots can make physiques look distorted, especially shot from above, like in this image. However, this cartoonish appearance looks charming and adorable with kids and pets. 15–85mm f/3.5–5.6 lens at 15mm, ISO 200, f/3.5 for 1/320 sec. I also applied several MCP Actions to this photograph.

For bonus goodies and information on this book's e-companion, visit CreateMixedMedia.com/artofeverydayphotography.

137

Photographers

Christina Nørdam Andersen is a girl for whom taking photos has awoken a curiosity and opened her eyes to the beauty that surrounds us, however discreet it may be. She is not really a street photographer, not really a photographer of people, as such, but of moods. Her imagery is subtle and emotive and always black and white. See more on Instagram: cirkeline and at christinanandersen.com

Daniel Berman is a photographer and film-maker with a background as a producer/director of music and nature programs for television. He brings a lifelong passion for rhythm and the natural world to his art. Daniel is the founder of the Mobile Photography Awards, the world's largest competition for mobile phone photography and art.

Lara Blair's book, *Photographing Dogs: Techniques for Professional Digital Photographers,* is available on Amazon. One of her favorite things is to teach a yearly Northwest workshop to photographers who would like to stand out in the crowd. You can view her work at larablair.com. Her personal blog, theextraordinarysimplelife.com, is where Lara waxes poetic about simplicity, good design and Airstream weekends.

David Booker lives in Derbyshire, England, where he works as an independent bookshop manager. His passion for photography began with film and home developing in his teens. He later delved into digital SLRs and Photoshop and now focuses on mobile photography. David's work can be found at blemishedeye.com and on Instagram: _blemish_.

Edgar Cuevas—from the Lone Star State—is the force behind iPhoneogenic. Edi Caves has been an active participant of mobile photography since 2009. He has exhibited his work internationally and was a participating and selling artist at the inaugural LA Mobile Arts Festival. Find Edi on his blog: itogs. wordpress.com, on Flickr: flickr.com/photos/ecaves/, on EyeEm: eyeem.com/edicaves or Instagram: edicaves.

Tracey Clark is a photographer, author, teacher and mother of two. She is the founder of Shutter-Sisters.com and the cofounder of OurCollective .org. Above all else, Tracey uses her photography as a practice to *Elevate the Everyday* and believes wholeheartedly that perspective—and love—changes everything. Find her at traceyclark.com.

Susannah Conway is the author of *This I Know: Notes on Unraveling the Heart* (Skirt! Books). A photographer, writer and teacher living in London, England, Susannah helps others reconnect to their true selves, using creativity as the key to open the door. You can read more about her shenanigans on her blog at susannahconway.com.

Dilshad Corleone—italianbrother on Instagram—is in love with Bresson's photography and his 35mm format; however, he considers himself to be a true mobile photographer. His street photography has been exhibited and won awards internationally. Recently, he was the main subject of an inspirational video in Barcelona, which was well received and can be viewed here: youtube.com/watch?v=HD7LTi1ZEn8

 Susanna Gordon is a Toronto-based artist and photographer. Her work has been exhibited in Canada and in the United States and in numerous books and magazines. To learn more, please visit her Web site at susannagordonphotography.com and her blog at susannassketchbook.typepad.com.

 Cindy Patrick is one of the most recognized names in iPhoneography and one of its most enthusiastic evangelists. Her work has appeared in numerous books and international exhibitions, and she has won some of the highest awards possible. Cindy is available for talks and workshops worldwide. See more of her work at cindypatrick.com.

 Thomas Kakareko is a mobile street photographer based in Berlin who loves black and white imagery. He has become one of Germany's most followed and recognized mobile photographers. Thomas's pictures have been shown in many exhibitions around the world and featured in various newspapers, magazines and blogs. See his work on Instagram: thomas_k.

 Celine Steen was raised in Switzerland and currently lives in Southern California. She blogs about vegan food at havecakewilltravel.com. She has written several cookbooks and is a self-taught freelance photographer. Her portfolio can be found at celinesteen.com.

 A Maine native, **Erin Little** is a motivated and innovative photographer. An artist by inclination and design, her images reflect a deep understanding of her subjects. A highly praised photographer, Erin travels coast-to-coast for her assignments. Her carefully constructed aesthetic sense is reflected in her sought-after images. Find Erin: erinlittleportfolio.com, alovesupremephoto.com, bluebirdbaby.typepad.com.

 Melissa Vincent began her interest in mobile art and photography in 2011. Interest turned into passion and now over 330,000 Instagram followers are inspired by her daily. Melissa was named as a top-ten finalist for the 2012 Mobile Photo Awards for artist of the year as well as the photo essay winner. Recently, her iPhone art led her to Botswana to photograph for National Geographic WILD Channel's Big Cat Week. Find Melissa at melissavincent.com and on Instagram: misvincent. Photo by Daniel Berman

 Vivienne McMaster is a photographer and workshop leader who focuses on helping people see themselves with kindness through their cameras, using self-portraiture as a transformative tool. She teaches online and in-person workshops, helping women to tell their stories and find their way home to themselves through self-portraiture. Visit her Web site at beyourownbeloved.com.

For bonus goodies and information on this book's e-companion, visit CreateMixedMedia.com/artofeverydayphotography.

139

Resources

More DSLR and mobile photography resources can be viewed online at createmixedmedia.com/artofeverydayphotography.

DSLR Photography

DSLR Manufacturers
Canon, Nikon, Sony, Olympus, Pentax

Lens Manufacturers and Lens Tests/Reviews
Manufacturers » Canon, Nikon, Sony, Olympus, Pentax, Sigma, Tamron, Tokina, Lensbaby
Lens Tests/Reviews » photozone.de

Camera Gear
adorama.com
bhphotovideo.com

Instructional Web sites
digital-photography-school.com
cambridgeincolour.com
thephotoargus.com
a great blog all about lighting » strobist.blogspot.com/
500px.com/flow
HDR tutorial with Trey Ratcliff » 500px.com/blog/750/
tutorial-learn-hdr-photography

Photo-Editing Programs and Tools for Mac or PC
Adobe Creative Cloud, Adobe Photoshop Creative Suite, Adobe Photoshop Elements, Adobe Photoshop, Lightroom: adobe.com
Pixlr free online editors » pixlr.com
CameraBag: nevercenter.com
Jixi Pix Software: jixipix.com
Nik Software: niksoftware.com
VSCO Cam: vsco.co/vscocam
Wacom Graphics Tablet » wacom.com
Noiseware® noise reduction software by Imagenomic » imagenomic.com

Mobile Photography

Web sites » Instruction/Inspiration/Sharing:
iphoneogenic.wordpress.com
iphoneographyCentral.com/
wearejuxt.com
amptcommunity.com
artofmob.blogspot.com/
lifeinlofi.com
mobiography.net
likesmagazine.com
theappwhisperer.com
mobilephotographyawards.com
ax3.cc
ourcollective.org (any camera type or device)

Books
The Art of iPhone Photography: Creating Great Photos and Art on Your iPhone by Bob Weil and Nicki Fitz-Gerald
Create Great iPhone Photos » *Apps, Tips, Tricks, and Effects* by Allan Hoffman

Magazines (paper and electronic)
Somerset Digital Studio
Shooter
Likes
Mobiography

Index

For bonus goodies and information on this book's e-companion, visit CreateMixedMedia.com/artofeverydayphotography.

141

DEDICATION

For Howie
For Elijah
For Rose
For Grace
I will love you eternally
from the depths of my heart.

Other fine North Light Books are available from your favorite bookstore, art supply store or online supplier. Visit our Web site at fwmedia.com.

18 17 16 15 14 5 4 3 2 1

DISTRIBUTED IN CANADA BY FRASER DIRECT
100 Armstrong Avenue
Georgetown, ON, Canada L7G 5S4
Tel: (905) 877-4411

DISTRIBUTED IN THE U.K. AND EUROPE
BY F&W MEDIA INTERNATIONAL LTD
Brunel House, Forde Close, Newton Abbot, TQ12 4PU, UK
Tel: (+44) 1626 323200, Fax: (+44) 1626 323319
E-mail: enquiries@fwmedia.com

DISTRIBUTED IN AUSTRALIA BY CAPRICORN LINK
P.O. Box 704, S. Windsor NSW, 2756 Australia
Tel: (02) 4560-1600; Fax: (02) 4577 5288
E-mail: books@capricornlink.com.au

ISBN 13: 9781440333699

Edited » Tonia Jenny
Designed » Brianna Scharstein
Production coordinated » Jennifer Bass

Thanks

Every book involves group effort and without the help of so many people, this book would not exist. My talented, innovative editor and friend, Tonia Jenny, has always been a supporter of my book ideas. Without her endorsements and belief in my work, I would not be publishing my fourth book with North Light Books. I appreciate her hard work, sound advice and freedom she gave me to write this book according to my own vision. I will always be grateful and indebted to this very special being. Thank you, Tonia.

I am thankful to all of the gifted people at North Light Books who have made the production of this book possible.

I would like to express deep gratitude to my dear friend and talented photographer, Susanna Gordon, for checking over those toughest chapters to execute—Chapters One and Two—the most technical.

Important friendships that did not wane despite my creative absences, I am so grateful for.

Thank you to all of the talented contributors who have given of their gifts to this book. Your sharing of your art and knowledge help to move so many people forward.

Thank you to all of the souls who allowed me to photograph them. It was a privilege to capture you. Thank you for trusting in me.

Readers, I thank you for taking a chance on this book. I cannot promise that it will meet your expectations. I can only promise that I have shared with you what is in my heart and what is important to me. If I can take the light I feel inside and with it light at least one other candle, then I have done my job.

I thank my beloved family lastly but certainly not leastly (my finale)—Howie, Elijah, Rose, Grace and Grammy Wendy for your continual love, words of encouragement and support, which came in many forms. A special thank-you goes out to my soulmate, Howie, for taking care of our family when I desperately needed more quiet time to accomplish the grand feat of completing this book.

LOVE!, Susan

About Susan

Maine digital SLR photographer and iPhoneographer Susan Tuttle has written three previous books with North Light Books: *Photo Craft: Creative Mixed-Media and Digital Approaches to Transforming Your Photographs* (2012, coauthored with Christy Hydeck), *Digital Expressions: Creating Digital Art With Adobe Photoshop Elements* (2010) and *Exhibition 36: Mixed-Media Demonstrations and Explorations* (2008).

Her mobile photography has won many awards and recognitions from venues like the prestigious American Aperture Awards (AX3) and Mobile Photography Awards. Susan's iPhoneography has been exhibited internationally in London, New York City, Prague and Paris.

In addition to authoring her own books, Susan is a frequent contributor to Stampington & Company publications and other North Light books. She was recently named technical advisor for *Somerset Digital Studio* magazine.

Susan shares her passion for photography and iPhoneography through online photography, iPhoneography and Photoshop/photo-editing workshops.

Visit her Web site and blog, susantuttlephotography.com, for workshop information, to learn more about Susan and her art, to get great free tips and advice on photography and explore lifestyle topics like gardening, recipes, DIY/craft projects, thrifty fashion and living the simple life with family. Susan can be found on Instagram as susantuttle, at Flickr: flickr.com/photos/ilkasattic, on Facebook as susan.tuttle.144 and on Pinterest as susant.

For bonus goodies and information on this book's e-companion, visit CreateMixedMedia.com/artofeverydayphotography.

143

Ideas. Instruction. Inspiration.

Receive FREE downloadable bonus materials at artistsnetwork.com/artofeverydayphotography.

 These and other fine North Light products are available at your favorite art & craft retailer, bookstore or online supplier. Visit our websites at artistsnetwork.com and artistsnetwork.tv.

Find the latest issues of *Cloth Paper Scissors* on newsstands, or visit clothpaperscissors.com.

 Follow Artists Network for the latest news, free wallpapers, free demos and chances to win FREE books!

Visit artistsnetwork.com & get Jen's North Light Picks!

Get free step-by-step demonstrations along with reviews of the latest books, videos and downloads from Jennifer Lepore, Senior Editor and Online Education Manager at North Light Books.

Get involved
Learn from the experts. Join the conversation.